Pens Ink & Places

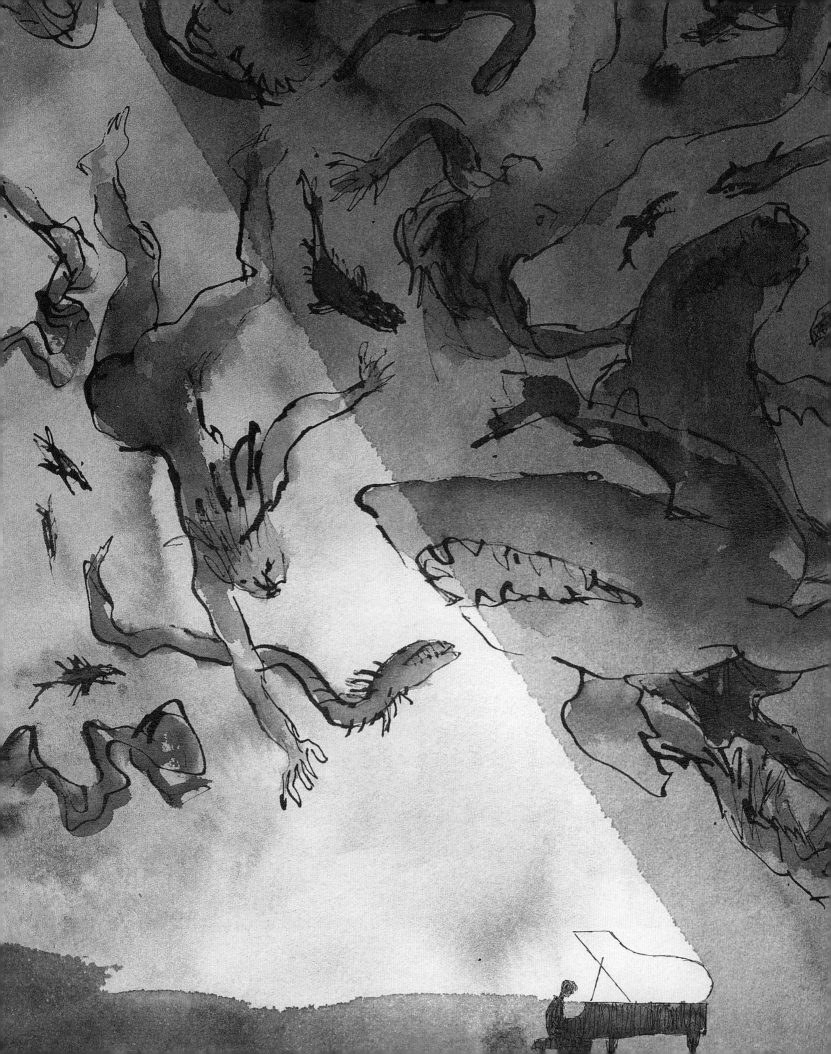

Quentin Blake *Pens Ink & Places*

A catalogue record for this book is available from the
British Library
ISBN 978 1 84976 638 8 (hardback)
ISBN 978 1 84976 639 5 (special edition)

Distributed in the United States and Canada by
ABRAMS, New York
Library of Congress Control Number applied for

Project Editor: Nicola Bion
Production: Bill Jones
Designed by Atelier Works
Colour reproduction by DL Imaging, London
Printed and bound in China by
C&C Offset Printing Co Ltd.

Cover: Artwork by Quentin Blake 2017
Frontispiece: Quentin Blake, James Blake tour poster
(detail, see p.211)
p.9: Halifax exhibition logo

Copyright

All artwork © Quentin Blake 2018

Credits

Andersen Press 28–33
The Folio Society 39–49, 51–9
Gallimard 184–5
Commissioned by the Mayor of London 194
Penguin Random House 13–17, 75–9, 102–7
Tate Publishing 24, 26–7, 37
Thames & Hudson 212–21
Walker Books Ltd 34–5
Didn't We Have a Lovely Time! by Michael Morpurgo,
illustrated by Quentin Blake. Illustrations © 2016
Quentin Blake. Reproduced by permission of Walker
Books Ltd, London SE11 5HJ www.walker.co.uk

Photo credits

Linda Kitson, endpapers

For
Liz Gilmore and
her colleagues

Thank You

I have many thanks to record to friends and collaborators, without whom much of the work in this book would never have happened, and most of all to Claudia Zeff and to Alexis Burgess, whose contributions, in their different ways, are everywhere through this book; also to Francesca Dow of Penguin Books, and to Jo Hanks and Liz Catchpole; to Dominic Gregory and Amanda Conquy, both formerly of the Roald Dahl Literary Estate; to Roger Thorp of Thames & Hudson and Nicola Bion of Tate Publishing; to Klaus Flugge of the Andersen Press, to Christine Baker of Gallimard Jeunesse, to Emmanuelle Dalyac of Editions Salvator, to Daniel Brennan, and to Dr Laura Wood also to Lucie Campos of the Institut Français and its former director, François Croquette. I am also grateful to Dame Mary Archer, Chair of the Trustees of the Science Museum, and to Shelley Bolderson and to Roz Wade of the Cambridge Museum of Zoology, as well as to Geoffrey Grimmett, Master of Downing College Cambridge, Susan Lintott, Senior Bursar, and the officers of the Blake Society. I am grateful, as ever, to Joe Whitlock Blundell and Sarah Culshaw; to Dick Edwards, and to Liz Gilmore, Kate Giles, Kim Kish and everyone at the Jerwood Gallery, Hastings. None of my activities would have been possible without the constant care and attention of Linda Kitson, and, in my office, Liz Williams, Cecilia Milanesi, Nikki Mansergh and Erica Read.

Foreword: 2 Granary Square

I can't begin this book without mentioning a place which has been important to me in recent years and which has a precise address: the House of Illustration at 2 Granary Square in King's Cross. It opened in 2014 with an inspiring director in Colin McKenzie and a gifted and imaginative curator in Olivia Ahmad. The only institution devoted to the art of illustration, it has an extensive programme of exhibitions, talks, seminars and education. As part of that programme it is active in encouraging students and young artists. Some of my work is also permanently on show there, but that is for the most part retrospective. This book is about what has emerged from my studio since the publication of *Beyond the Page* in 2012.

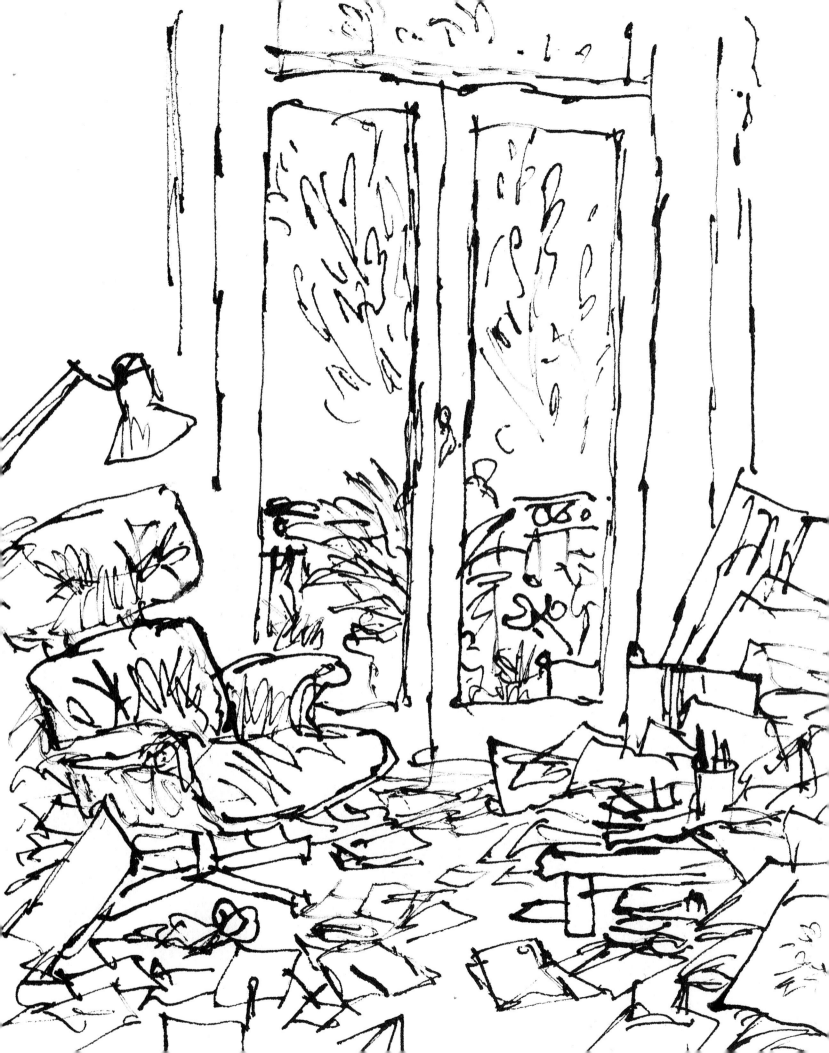

A London Square

The majority of my illustrations over the past forty years – and that must be thousands by now – have been produced in a room overlooking a tree-filled London square. The room looks out over the square, but I don't. While I am drawing I stand with my back to the French windows and the balcony, pen in hand, trying to imagine myself into the scenes and activities I am depicting.

There are four plan-chests in the room and two desks, and numerous piles of drawings. Correspondence, nowadays mostly in the form of emails, is mixed in amongst them, sometimes for quite long periods of time. However, in early 2015 I received something rather different – a typed letter bearing the ornate letterhead of the publisher Frederick Warne, and signed by Francesca Dow, the managing director of Penguin Books, of which Warne is now a subsidiary, and a valuable one, since they have always been the publisher of Beatrix Potter. The letter was accompanied by a facsimile of her original manuscript of *The Tale of Kitty-in-Boots* with an explanation that for some reason Beatrix Potter had never illustrated the book, beyond a single picture, and an invitation for me to produce a set of illustrations so that it could be published to celebrate Potter's 150th anniversary in 2016.

I cannot say I had no qualms about accepting the task, because Potter's mantle is an impressive one to wear, even for a short while, but I had no hesitation; it was just too interesting. The invitation also came adorned with two curious coincidences. I live within five minutes' walk of Bousfield Junior School, where I have attended the last assembly of the school year – it must be for twenty years by now – to help give out books to the pupils who are leaving. There are some versions of my pictures painted on the playground walls by the children's parents, and some of my drawings hang framed in the school. More important than this, however, is the fact that on the outside wall

of the playground is a plaque showing Peter Rabbit, because it was in a house on this site that Beatrix Potter spent her youth. Another smaller but welcome coincidence was that Kitty called herself (even though it isn't the spelling I favour) Miss Catherine de Quintin, and Cheesebox calls her Q, which is the name I have among members of my family and friends. I was able at least to try and persuade myself of the innocent fantasy that Potter might have left the story especially for me: there was certainly more knockabout activity and airguns exploding than you would normally associate with our author. There was no point or possibility in relating my way of drawing to Beatrix Potter's, though when Mrs Tiggywinkle and Mr Tod appear I hope that their depiction is faithful to the original. And in every respect of layout and format we tried to make the book as much like its twenty-three great predecessors as possible.

Preliminary drawing for The Tale of Kitty-in-Boots

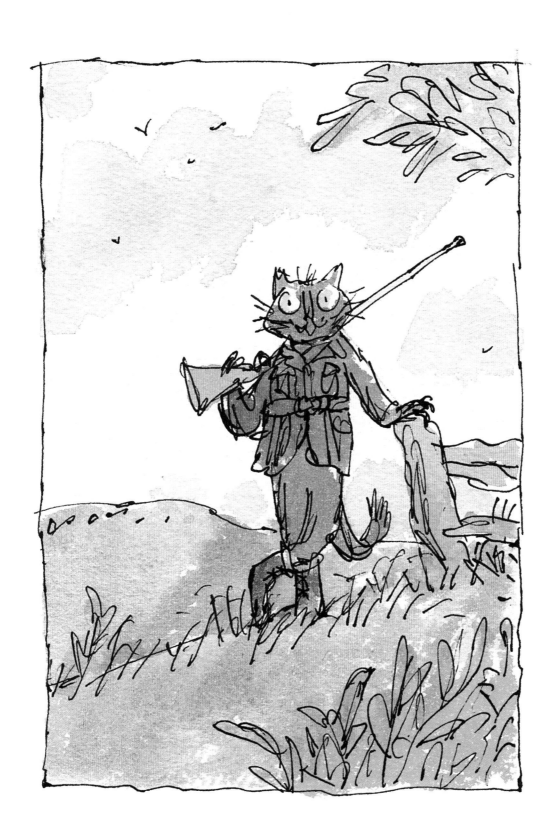

A further walk of twenty minutes or so towards the centre of South Kensington brings me to the Institut Français. It's very gratifying to have a taste of France close by, and I have even had the illusion (as I illustrated once for an Institut publication) on entering the building of getting younger and becoming momentarily almost a student again.

Every year in November the Institut runs a festival of books and cultural activities for young people, in both languages and sometimes several more. Somehow I got involved at the start, twenty years ago, and ever since I have been its patron (or, as I suppose the French would say, *parrain*). I have also given talks and engaged in live drawing matches with visiting French artists, friends such as Bruno Heitz, Philippe Dumas and Joann Sfar. A few years ago the Institut set about refurbishing its library, and I was invited to take part in a fundraising dinner for French businessmen and benefactors. This was one of the rare occasions on which I wrote out what I had to say. What I put forward for their consideration was not solely for fundraising purposes, but something I firmly believe; and so, as I have it to hand, I hope it will be acceptable if I quote part of it here:

> Although a 'bibliothèque de jeunesse' may be relatively small and cheerful, it is nevertheless extremely important. It's an amazingly effective implement of education because it invites

Bibliothèque Quentin Blake wallhanging (detail)

children to make their own explorations into reading, pursue their own tastes and initiatives – it's like a machine that creates its own energy.

Roald Dahl describes in *Matilda* some of the effects of the wonder of books, the access to new worlds. I think we need to say that they also have – and I feel I want to say this in French – an *aspect philosophique*. They speak of the way people live and by implication how we ought to live. An apparently simple album, *mine de rien*, will have some moral dimension, however simple.

I also drew a book, looked at it and observed, 'It must be a *livre magique*'; to which it was irresistible to add: 'But then all books are magic.'

The junior library was in due course also refurbished and enlarged and became important to me in a special way. I think I have a pretty good idea with whom the suggestion originated, but what I remember was a meeting with the then director of the Institut, François Croquette, and his assistant, in the Institut café. Would I consider giving my name to the reopened junior library? Not a doubt in my mind about the response. I treasure the two medals I have been awarded by France, but this is an honour that is unique.

I wanted to express my appreciation by creating a wall hanging for the library, of assorted children. For decorative purposes they are all perched in trees, where they are reading, reading to each other and being read to. In the top right-hand corner I incorporated a bird with books in its beak, which flies off on its own to become the logo of the library.

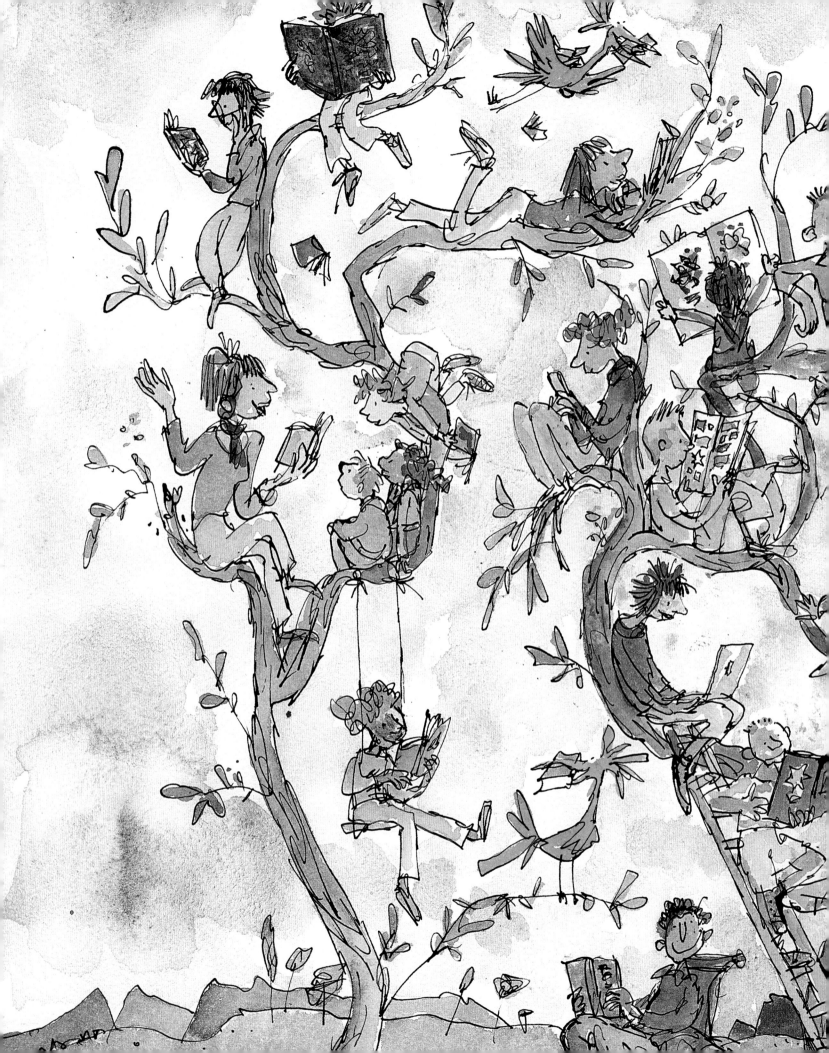

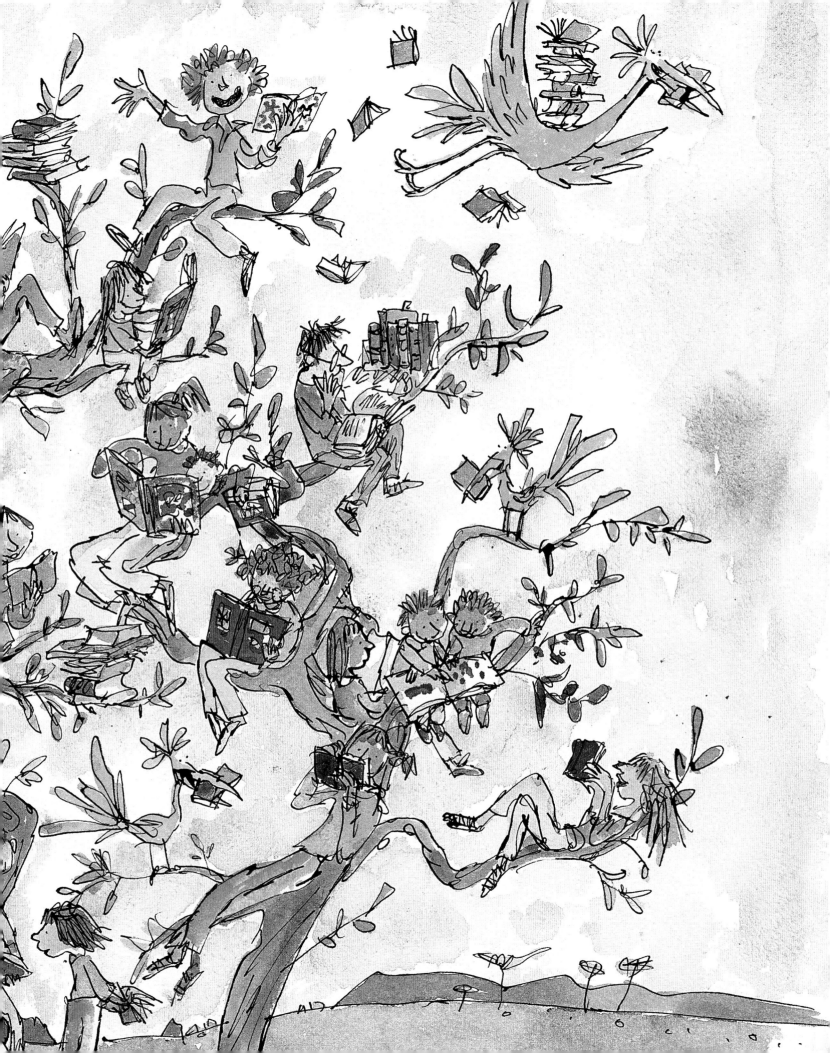

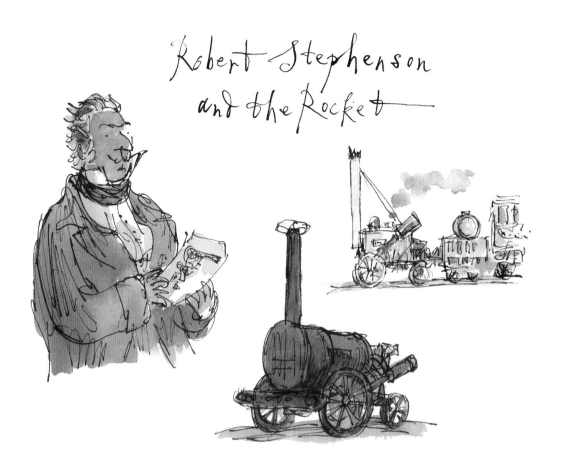

Robert Stephenson and the Rocket

Another five-minute walk in this tour of South Kensington brings us to the Science Museum where, in 2016, Dame Mary Archer had just arrived as chair of the board of trustees. We had already become acquainted when I was working on my sequence of pictures of 800 Cambridge alumni. Now she had in view something that I might be able to do for the Science Museum: a sequence of panels in a public room, where she could envisage a set of portraits of the scientists and inventors whose creations were owned by the museum – Stephenson and his Rocket, Arkwright and the spinning machine. Amy Johnson was an exception to the rule, but her aeroplane is one of the most dramatic exhibits in the museum, and she and it demanded to be drawn.

All that was left for me to do was to get reasonably convincing portraits of the protagonists (plenty of useful whiskers) and reasonably convincing (though relaxed) drawings of their inventions. What I also had to take into consideration was that the drawings would have another, and in some respects even more important, function when they appeared on items of merchandise in the museum's flourishing shop. It was another of those interesting situations in which drawings produced in the studio find themselves both much smaller and much larger in life.

From the The Science Museum mural

Cooke & Wheatstone
and the Electric Telegraph

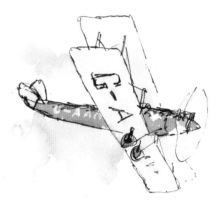

Amy Johnson
&
"Jason"

Richard Arkwright
and the
Spinning
Machine

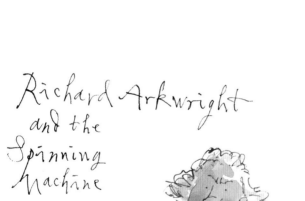

23

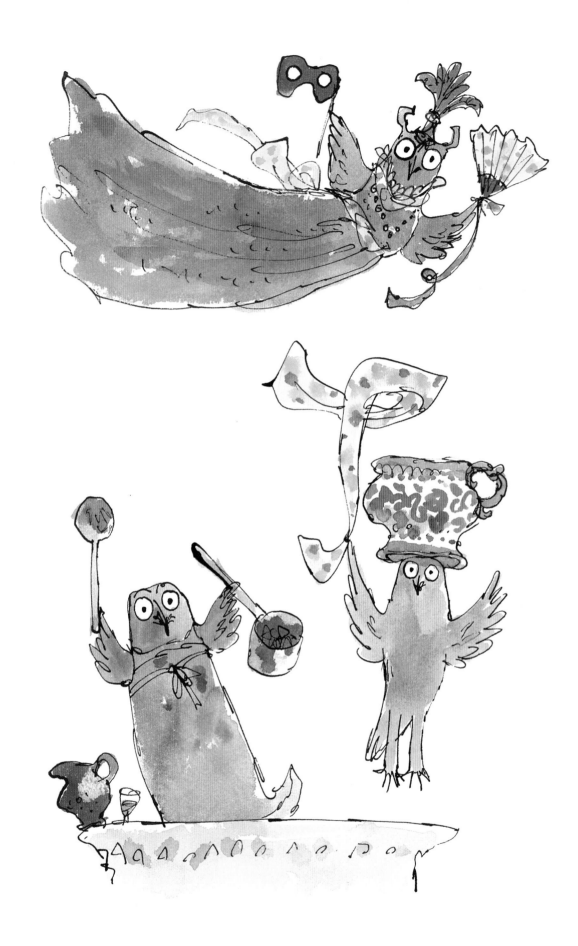

Genoa and Elsewhere

In 2009 I had the good fortune to have an exhibition of my work at the Museo Luzzati in Genoa, housed in a fourteenth-century fortress on the seafront. Several of the drawings I produced specially for the occasion are illustrated in *Beyond the Page*, and there was a handsome catalogue of the show designed by Luigi Berio, who runs his design business Arteprima from a medieval tower within sight of the museum.

All this was enjoyable enough, but Genoa had something else to offer me, which didn't happen until later and which I hadn't foreseen. Despite his international reputation as an illustrator and theatre designer, Emanuele Luzzati had lived and worked for the whole of his life in the same house in Genoa, and after his death the entire contents were transferred to the museum. Among the manuscript material was a nonsense verse – his own version of a traditional rhyme, 'Tre Civette Sul Comò' – which Luzzati had probably meant to illustrate. On my visit to Genoa, Sergio Noberini, the director of the museum, invited me to take on the task. The book would appear in Italian but we also wanted to create an English edition, and three owls on a chest of drawers became *Three Little Owls*.

I worked on my drawings from a literal translation. John Yeoman also had it in front of him as he set about creating parallel English nonsense verse.

One of the things that was interesting to me about the book was not only the assortment of objects and costumes associated with the Owls, but also the variety of landscapes through which they flew. I arranged for each of them to have a property – a fan, a scarf, an umbrella – so that when they set off on their travels we could recognise them by their curious silhouettes. It was enjoyable, too, to have

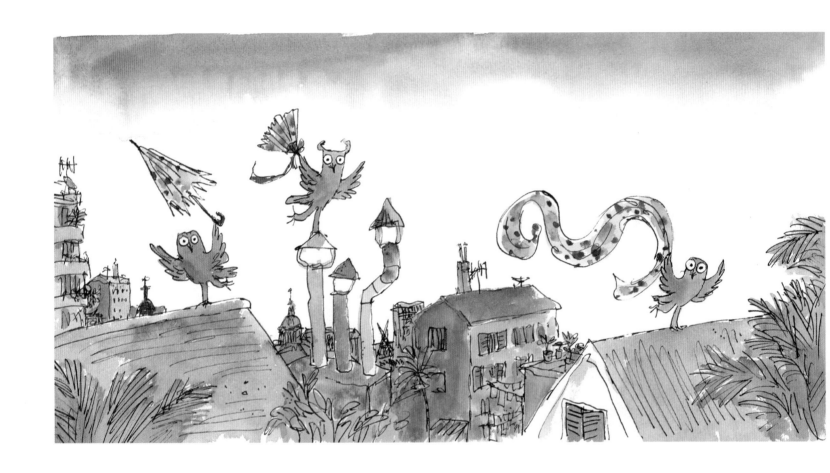

Three Little Owls

city views (including buildings direct from Genoa) as well as distant exotic landscapes. And for once, I found myself not having to draw expressive dots for the eyes. The three owls preserve their expression of astonished serenity whatever is happening.

Two other books that John Yeoman and I produced at about this time both involved a return in some way to existing material. I had done a set of drawings for a centre for elderly mental health patients in which their visual counterparts were engaged, in relaxed and dignified fashion, in a range of circus activities – juggling, tightrope walking, fire breathing. I had already included young people in the hospital pictures and now I added more as spectators and participants. John Yeoman found himself writing words to the pictures, not for the first time, and we called it *The Fabulous Foskett Family Circus*.

The Fabulous Foskett Family Circus

Our most recent collaboration, also published by Klaus Flugge at his Andersen Press, is a new book partly based on existing words and pictures. Several years previously our friends at the publishers De Fontein in Holland invited us to create a Quentin Blake *Agenda*. I drew subjects loosely associated with the months, and John wrote verses which were then translated into Dutch. The pictures also appeared in a Gallimard diary, *Douze mois pour rire*, but sadly no one seemed to want our work in English.

I confess it took me rather a long time to realise where the answer lay – that we had all the elements of a book about the seasons. It became *All the Year Round*. One important modification was some rewriting so that the concluding line came as a surprise when you turned the page. I was delighted that at last we had the words in English, from the energetic boy in his January running kit to November's dressing up and the cheerful boy getting into bed in December to stay there until it's spring once again. And when, for the month of May original the subject of a girl riding her bicycle seemed rather too sober, my author supplied me promptly with an unexpected scene of heart-wrenching pathos.

All The Year Round

All The Year Round

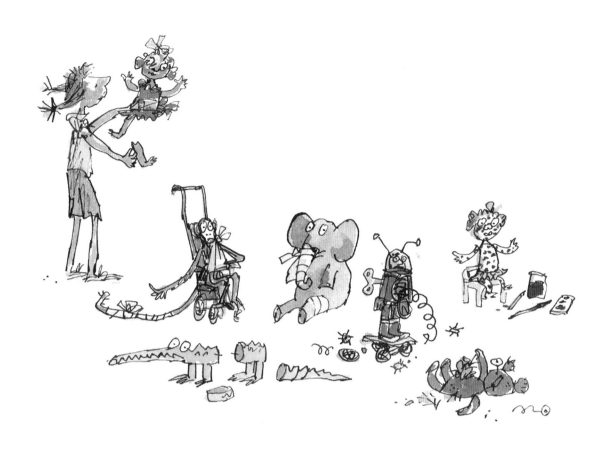

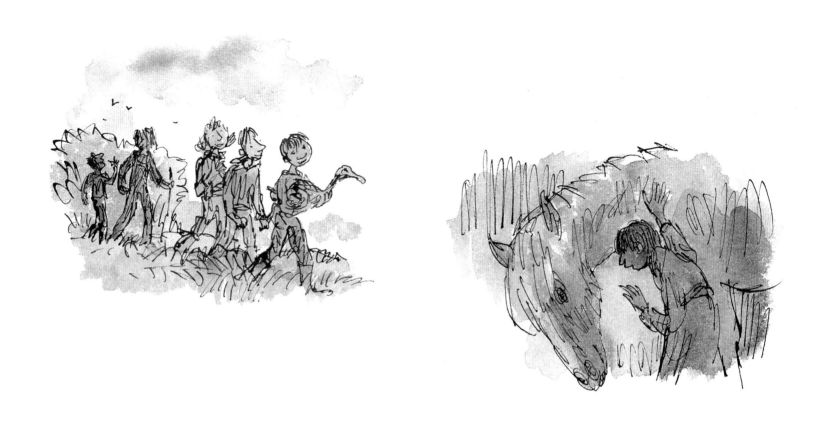

Didn't We Have a Lovely Time!

A very different kind of pathos is present in Michael Morpurgo's *Didn't We Have a Lovely Time!* I have worked with Michael on two anthologies of verse and his Christmas story *On Angel Wings*, as well as drawing the little girl with her ducks and geese who is the logo for Farms for City Children. Consequently I had no hesitation in saying yes when he asked me if I would illustrate a story he had written to celebrate forty years of the charity. The story is based on an actual incident, now re-imagined to give it a broader relevance. The teacher of an imaginary class on a visit recounts what happened – 'I felt I had to write it down' – to Ito, the Vietnamese refugee boy who finds his voice in talking at night to the horse, Hebe. An additional interest of the task for me is, once again, adapting my own way of drawing to the circumstances. Here it is important that the viewer has a sense of the reality of the situation, that these are real adults, real children, so that one might almost feel that the drawings were made from life.

No attempt at reality, by contrast, in *The Five of Us*, though the circumstances it responds to are real enough. A few years ago I was invited to take part in an exhibition organised to draw attention to the rarity of disabled children appearing in children's books. By request I drew two pictures of children using walking aids, as I might perhaps have illustrated them as part of some narrative. Later, when I found myself for some reason once again asked to consider the question of disabled children in picture books, I thought: 'Let's not just have them on the margin – why can't they be the main characters?'

And so they were, as I invented them: five children, each of whom had his own disability, none of which is mentioned. I am aware that compensatory abilities are not automatically present in real life, but for my characters they are: Ollie, despite his thick spectacles, can hear a sparrow sneeze miles away; Magnus, whose wheelchair we don't acknowledge, is terribly strong; and so on. The plot of the story is put together from the traditional folk tale, which exists in several cultures, of five friends, or servants, or brothers, each of whom has an extraordinary ability.

Tom Maschler at Jonathan Cape had been the editor of my picture books for thirty years and so he was the first person to whom I showed my rough version. That he didn't express anything by way of enthusiasm for it, albeit without specific comment, didn't come as much of a surprise to me. He no doubt sensed what one can think of as its artificiality, its aims as propaganda. I still thought it had its own value, and so, I am happy to say, did Roger Thorp and Nicola Bion at Tate Publishing. There were also foreign publishers who must have felt the same about the book, as it now exists in French as *Pas de panique!*, in Italian as *I fantastici cinque*, in Spanish as *Nostros cinco* and in Turkish as *Beşimiz*.

I don't know how much the book has been found useful, but I know that a school for deaf children I visited in North London had bought enough for a whole class; and, perhaps most gratifying, was happening to meet a father who had bought copies for his two sons, each of whom had some disability.

Preliminary drawing and notes for The Five of Us

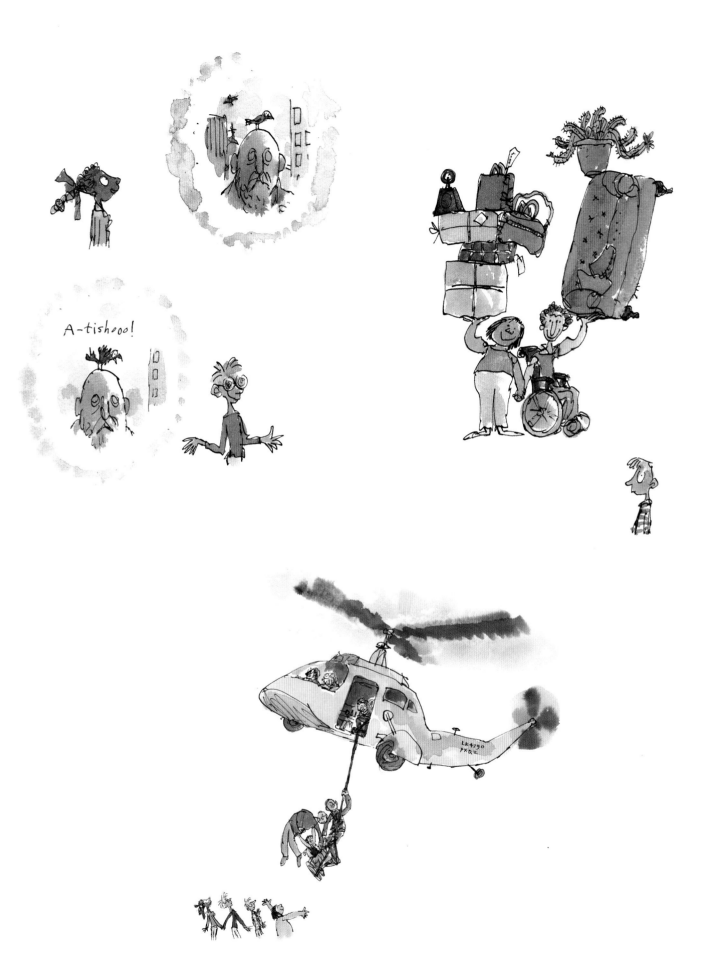

A-tishooo!

Appointment in Eagle Street

I am aware that, in comparison with the previous sections of this book, the title of this one has something of the spurious about it; I hope for the reader's indulgence, since the books I want to talk about take place in, among other places, Ancient Greece, seventeenth-century France, and a desolated county of Kent centuries after a nuclear disaster. But they are all published by the Folio Society, whose head office used to be at 44 Eagle Street in Central London, and I also have to confess that my visits there have not been frequent over the years since I first illustrated *The Hunting of the Snark* for them in 1976. It was after I had started being commissioned by the Folio Society that it was bought by Bob Gavron (Lord Gavron), who transformed it and gave it a new vitality. My direct collaboration on books, however, after the early years, has always been with Joe Whitlock Blundell, and those meetings were as likely to be with him arriving by bicycle at my studio, or at the French Institute, or some other (as he might say) congenial rendezvous. I have illustrated altogether twelve books for the Folio Society but it is only in the recent few years that I have worked on a new development, the deluxe editions. The first was Voltaire's *Candide* and my particular good fortune was that its thousand (numbered, signed) copies sold out in about a fortnight, which meant that I was invited to propose an appropriate sequel.

It did not take me very long to settle on another French text, a selection of fifty fables of La Fontaine. My impression is that the fables have been illustrated by every French illustrator of note, but, with the exception of the great Gustave Doré, as books for children. Many of the fables – there are many well-known ones, such as 'The Grasshopper and the Ant' and 'The Fox and the Crow' – are suitable for a young audience, though in fact many are obviously directed at adults. The fables must have been a relaxed form of entertainment, with an air of (it's hard to find a suitable word that isn't French) *insouciance, désinvolture*. They were both innocent and knowing. I wanted to illustrate my

Riddley Walker

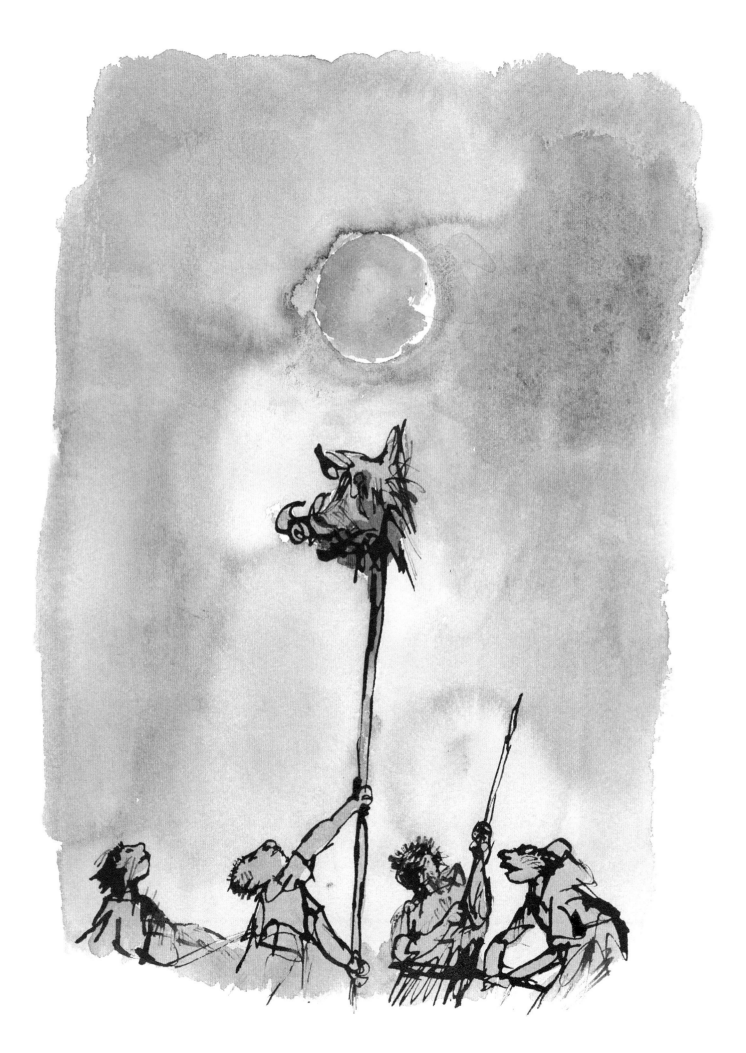

fifty fables, chosen from many, many more, as evidently for adult readers, and there were plenty of suitable subjects. A number of them in fact do not have the Aesopian moral that one has come to expect, but are really very short stories with a twist at the end. Such, for instance, is 'The Wife and the Drunkard'. When the husband is unconscious with drink she transfers him to the cellar of the house, which she has done her best to make look like a department of hell, and as he begins to regain his senses she arrives disguised as Satan's cook, bringing him something hideous to eat. His response: 'Nothing to drink?' The idea of someone who reacts in line with their deepest instincts occurs again in the fable of the young man who is so adoring of his cat that he manages (we have to accept the premise) to get her changed into a woman so that he can marry her. Everything goes well until the night when there are mice in the bedroom. Similarly, in 'Death and the Woodsman', the woodsman despairs at managing his load of wood and calls on Death. She arrives and asks what she can do for him. 'You couldn't help me with the logs, could you?' In fact, part of the wonder for me of this La Fontaine book was the opportunity to illustrate the denouement of fifty different stories, fifty different delicately observed situations.

Fifty Fables of La Fontaine

My next venture for the Folio Society was another of my own suggestions: *The Golden Ass* of Lucius Apuleius. In fact I was reacting to a friend who wondered whether the story of Cupid and Psyche might appeal to me. I went to look for it and found it among many others in *The Golden Ass*. I found also that it had been illustrated fifty years before by my friend and colleague Brian Robb, in an edition which, curiously, left out Cupid and Psyche. That, to me, would have been a disappointment, since part of the interest of the venture is the contrast between that romantic lyrical encounter and the very down-to-earth physical activities which occur elsewhere throughout the book – from Cupid and Psyche to Fotis, the fetching servant girl decorated with roses, and the wealthy young lady who hires Lucius for the night.

There was also, however, an especially rewarding opportunity in the design of the binding. For Voltaire and La Fontaine I had made use of hugely enlarged handwriting, but here there was one image, scratched on to the paper with a quill, that claimed priority – Lucius as the Golden Ass himself, with roses in his mouth.

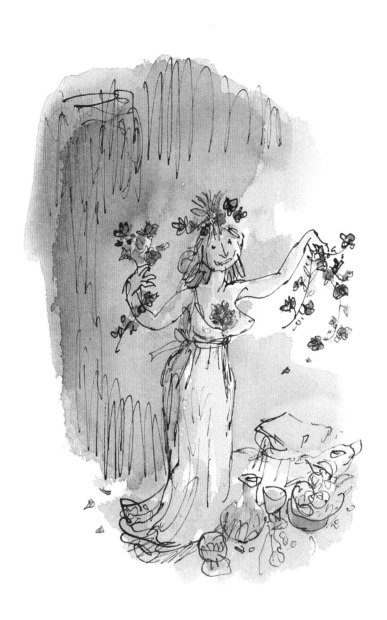

The fourth deluxe edition I undertook for the Folio Society was perhaps as different in mood and treatment as can be imagined: *Riddley Walker* by Russell Hoban. This time the suggestion came from Joe Whitlock Blundell, who had recently discovered the book and was enormously impressed and taken up with it. Probably no one but Joe would have commissioned me to do it, but I did in fact already have some sort of qualification for the job. I had illustrated a number of Russell Hoban's children's books during his lifetime, and had visited him at his home on Eel Brook Common and got to know him quite well.

More, even, than that, perhaps, the paperback copy of *Riddley Walker* that I had originally read had a dedication to me from RW himself, and for me nothing could have been a better authorisation.

DRAW IS AN INTERSTING WORD. THERE IS DRAW MEANING FETCH OR PULL AND THERE IS DRAW MEANING DRAW A PICTER. THERE IS THIS BLOAK QWENTING BLAKE WHICH HE IS A TOP DRAWER BOATH WAYS HE CUD DRAW YOU ANY THING YOU CUD THINK OF AND LOTS YOU CUDNT. PUL THEM LIKE RIGHT OUT OF THE AIR AND ON TO THE PAPER. *RW*

By coincidence I had, once, already drawn Riddley Walker. For one of its Christmas editions in the 1980s, the *Times Educational Supplement* had had the inspiration to invite Hoban to write five short pieces about Christmas in the style of five of his books; *Turtle Diary* was there, as was Captain Najork, and, in his own vernacular, Riddley Walker. Looking at the drawing now I find him not so different from my new depiction – perhaps a shade too primitive and stunted for present purposes, but the same person.

Even so, setting about it was not altogether a simple matter. To begin with, what might be called the logistics. My experience was that, reading *Riddley Walker*, you get into the habit of the kind of degraded speech of its narrative, and you almost begin to talk it to yourself and become familiar with the idiom. What is not so easy is to move about from one moment to another, picking up the details you need, and I might well have foundered if I had not had the help of Jake Wilson. He is a picture researcher, a musician and, towards the end of Hoban's life, a friend with whom Russell discussed the writing he was working on. What Jake Wilson produced was a detailed synopsis, accompanied by useful visual reference. With this guidebook, as it were, in one hand, and the original text in the other, I could move forward.

One of the next concerns was how to reflect the primitive nature of the work. It is written by Riddley Walker himself, and for a while Joe Whitlock Blundell, all his book-production instincts on the alert, seemed to want to believe that he had printed it as well. I think as he saw it, burnt and distressed, it might have made an impressive work of fine art. I wasn't sure that in that form it would be welcome on the shelf of a Folio bibliophile; or how we could relate it to an awareness that the book was being illustrated by someone not Riddley. What I proposed first of all was to make the binding look not battered so much as infected, decaying but still decorative.

In general it seemed to me, although the story is full of incident, it should be the atmosphere that took precedence. There was no shortage of opportunity for atmosphere, as we are in a ruined landscape, and it is dark and raining. A suggestion by Joe Whitlock Blundell matched well with my thoughts – that, though all the illustrations would be printed in full colour, they would be drawn in

shades of black and sepia with only rare moments of intense colour. They are all drawn with quills, of assorted levels of deterioration, which I hope contributes to the sense of the primitive, although with one in your hand it is also possible to be quite precise in expression and gesture. The shapes of the illustrations are in the same spirit: large and awkward – too awkward to respect the formal areas of the text. Several of them stretch across the bottom or the top of two pages. A sympathetic editorial eye took the last sentence on to the last double-page spread, so that we can see Riddley walking on into the track of his future.

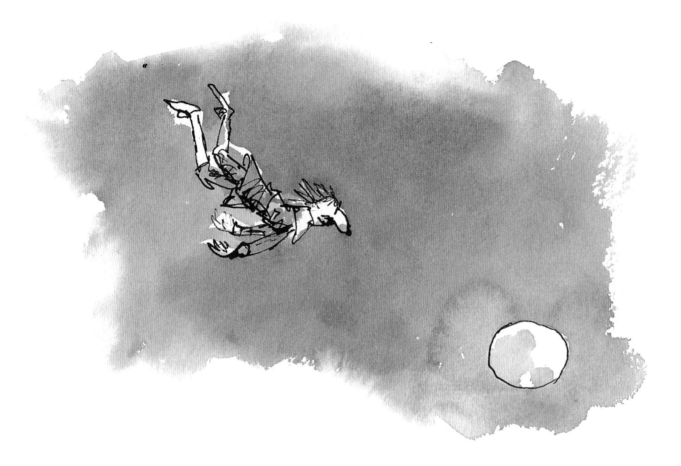

Two or three of the books I have illustrated for the Folio Society were my own suggestions; and curiously I have suggested one book twice – Cyrano de Bergerac's *Voyages to the Moon and the Sun.* I was very pleased when it was first published in 1990. I had been allowed to produce a large number of drawings (something unusual in those days for the Folio Society) and Joe Whitlock Blundell and I had sat together, tucking them in to the pages and working the text around them. There was only one small element of dissatisfaction, in that somehow the two small drawings of the moon and the sun from the cover had become repeat pattern for the endpapers, where what was needed was plain dark pages to contrast with the activity of the drawings that follow.

However, my main incentive was not to get rid of a minor defect but something larger and more positive. After the experience of four deluxe editions, it was not hard for me to imagine Cyrano transformed into such a volume – and that is what I proposed to Joe Whitlock Blundell. The answer he brought from his colleagues at Folio was favourable, but what they wanted was not a deluxe edition but rather an enlarged and enhanced version of the book. I was quick to realise that this was a better solution by far: we would have a book at a manageable price, and even more people would have the opportunity of making the acquaintance of Cyrano.

The drawings now had elbow room on the page. Some I redrew because I thought I could improve on the original version; one or two I redrew because I had misread the text twenty-five years ago. There were altogether twenty new drawings. Along with plain endpapers, a golden sun would emerge from a dark slipcase, and one of the most fascinating books I have had to illustrate was in print again.

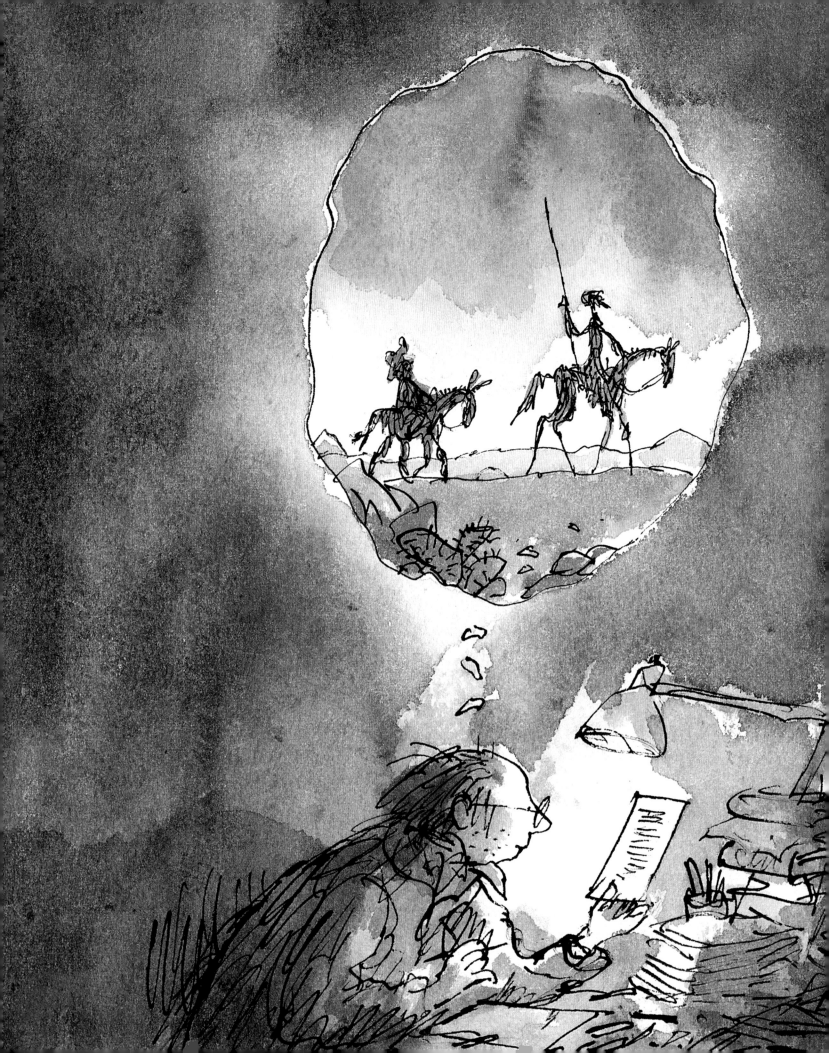

Cambridge

Cambridge has offered me two rewarding projects: one about a heraldic beast and one about real creatures, and within ten minutes' walk of each other.

In recent years I have revived my association with my old college, Downing. Initially I did one or two drawings for the merchandise which the Alumni Association sells to raise money for student grants, making use of a griffin, which is the heraldic beast of the college. Whether spelt griffin or gryphon, the visual possibilities seemed to deserve more than that, and I found myself embarked on a whole series of drawings – variously depicted and coloured, and perhaps a bit more animated than heraldry might allow. And then one day Susan Lintott, the Senior Bursar of the college, invited me to come and look at the Grace Howard Room. This is a room for gatherings of all kinds in a new building, designed by Quinlan Terry and named for Grace Howard in acknowledgement of the generosity of George Howard, her husband.

At one end of the room there are large drawings by Francis Terry of the heads of two griffins facing each other. In reality they are flat, but such is the accuracy of the trompe-l'oeil drawing that they appear to be in bas relief. They are extremely striking. Susan Lintott took me to the wall at the other end of the room and, as far as I recall, said hardly anything; but the implied invitation carried its own brief within it. Or so at least it seemed to me. My response was two scratchy drawings of griffins rampant, with subdued colour that was evidently watercolour. Then I called on Burgess Design, and my griffins became wall hangings, with the use of a mechanical process that produces the effect of tapestry. I confess that there was something that appealed to me in the idea of two small informal drawings translated into the traditional formality of tapestry. I don't know if that will have the same effect on the visitor, but I hope my griffins will hold their place in comfortable contrast with those of Francis Terry.

Cover for the RSL Review

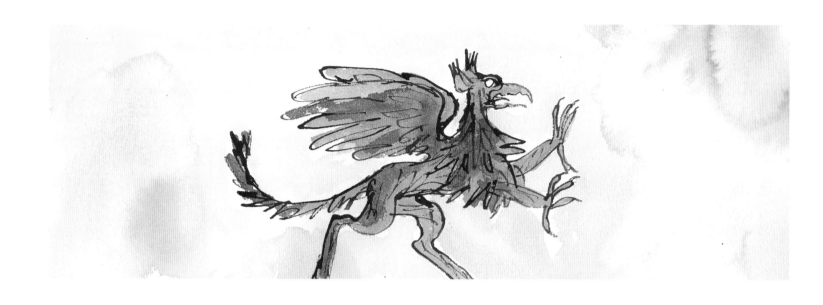

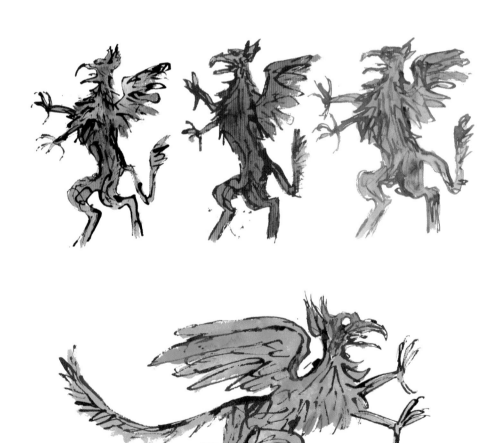

Downing College tapestry

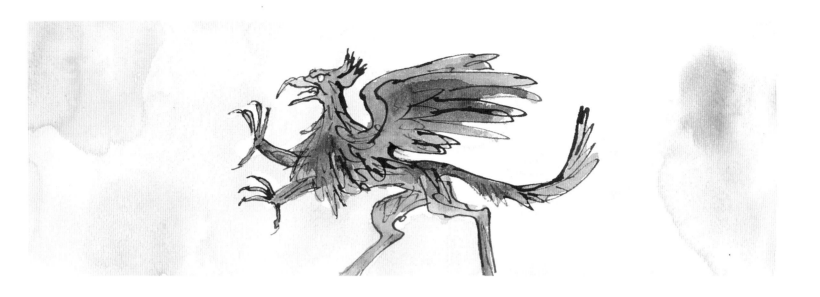

In 2015 Downing College took the imaginative step of establishing an art gallery in its grounds (on the domus, as they describe it). It was first prompted by the Cambridge City requirement that 1 per cent of the budget of refurbishments – in this case a row of shops converted into college rooms – be spent on art; but Downing's Heong Gallery owes its name to Alwyn Heong, an alumnus whose generosity helped to make it possible. It is now, along with Kettle's Yard, one of the two galleries in Cambridge which run a programme of regular art exhibitions. The existence of the Heong Gallery has also served to revive relationships with a number of alumni involved in the world of art, and led naturally to a sequence of exhibitions made possible by them. The first, for example, was of modern British paintings in the collection of Alan Bowness, former director of the Tate Gallery.

In due course, thanks to the initiative of the Folio Society, there was an exhibition of the four deluxe editions that I had illustrated for them, with the happy title provided for it by Susan Lintott: *The Best of All Possible Worlds*. I was able to include a print of a drawing I had produced for the cover of the journal of the Royal Society of Literature, where I imagine myself with pen in hand, thinking about Don Quixote and Sancho Panza. What I could not have anticipated was that, at about the same time, the editor of *Varsity*, the student newspaper, invited me to draw a cover to celebrate their seventieth year of publication. As I had all the Folio characters ready to hand, it was easy and enjoyable to bring them all forward (even Dr Pangloss) to raise a glass to toast the occasion.

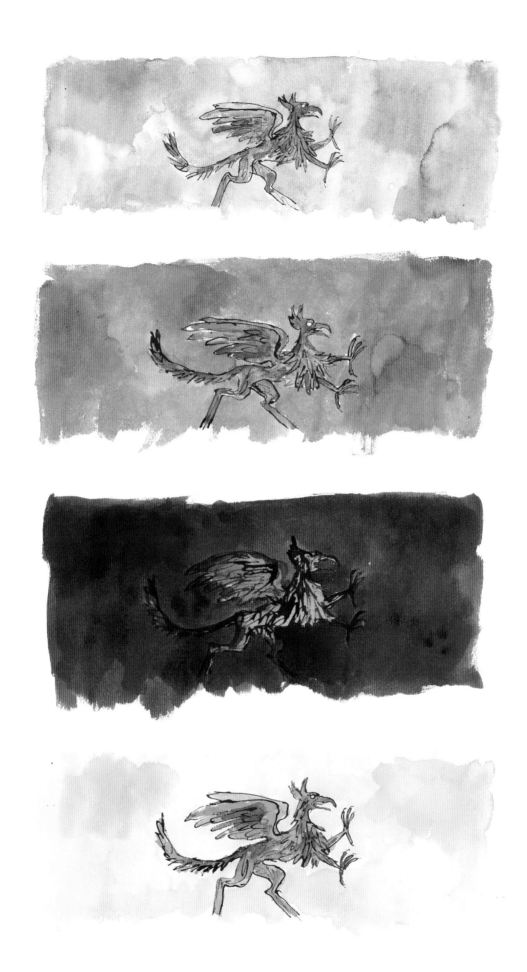

Downing College tapestry: studies of Griffins

Happy 70th Birthday!

in this Best of All Possible Worlds

from Quentin Blake and

Dr Pangloss
Candide
Cupid
Riddley Walker
Photis
Cyrano de Bergerac
The Garden Lover & the Bear

Cover for Varsity magazine

If you turn left out of the front gate of Downing College and walk along Regent Street you come, on your left, to Downing Street, where there is now the modern building that is the home of the University of Cambridge Museum of Zoology. I had worked with Shelley Bolderson on the Cambridge 800 project, and on her arrival at the Zoology Museum she had the idea that there might be something appropriate for me to do there too. I set to work on a set of drawings for the blinds that hang inside the building at first-floor level around the central atrium. These blinds are permanently lowered to keep light off the specimens on display on the ground floor. My drawings show visitors to the museum encountering them, as though in real life. An advantage of this was that we could show creatures such as the dodo and the giant sloth as they would once have looked, although they only exist in the collection as skeletons. I discovered that there is also a wealth of anecdote associated with the museum's specimens, so that I was able to show some of the original naturalists – Darwin appears more than once – along with their discoveries, and even side by side with present-day visitors.

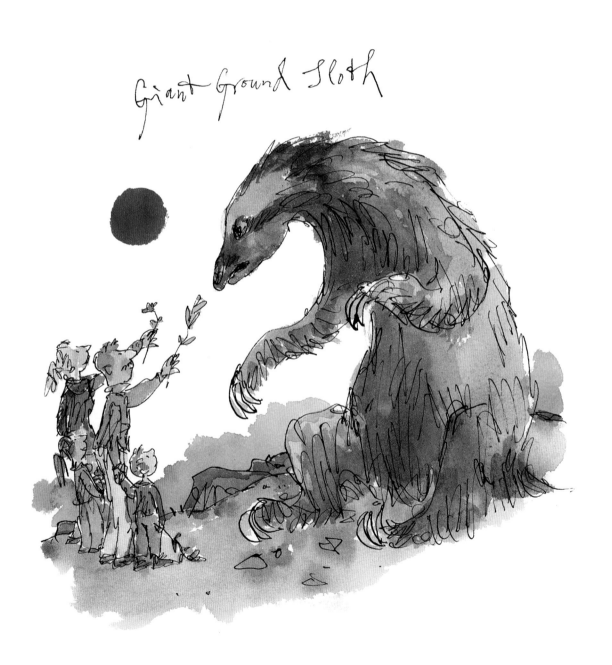

For Cambridge University Museum of Zoology blinds

Dodo

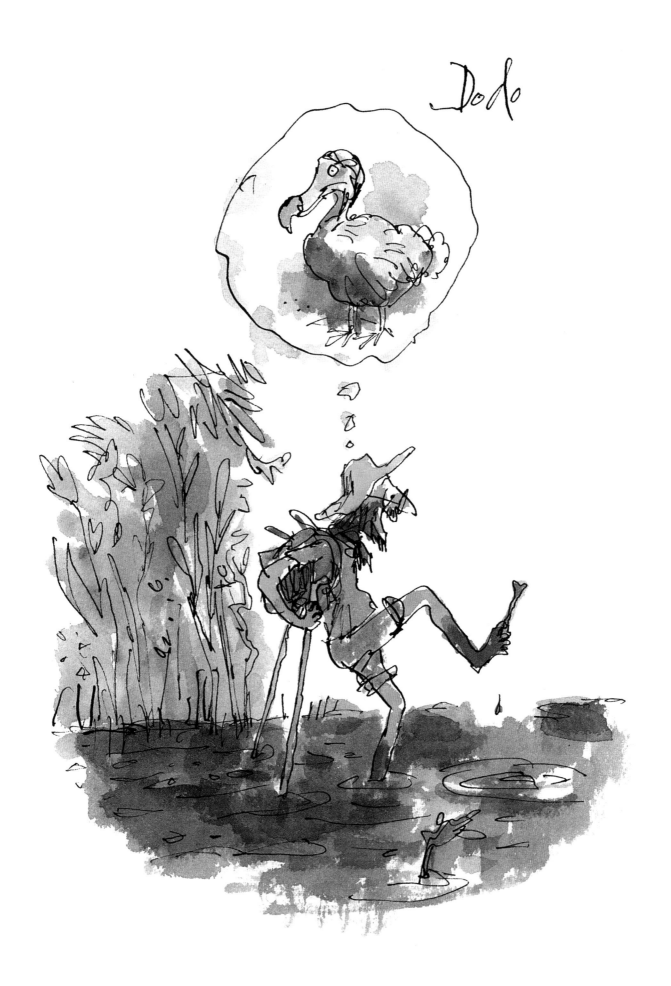

Leafy Seadragon

Spotted Porcupinefish

Giant Spidercrab

Komodo Dragon

Aldabra Giant Tortoise

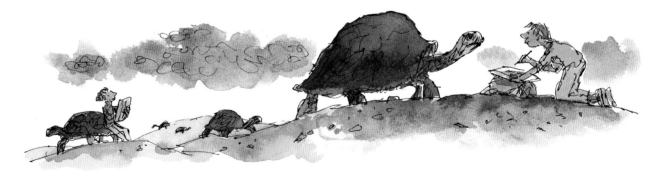

Kakapo

Pale-throated three-toed
Sloth

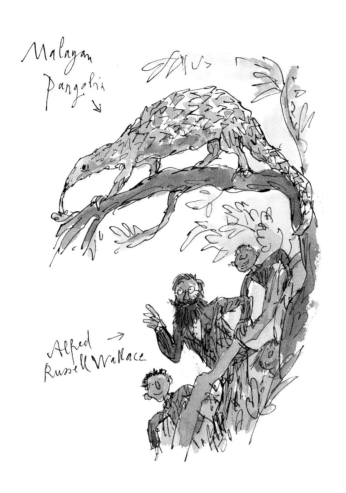

Malayan
Pangolin

Alfred
Russell Wallace

Darwin's Beetles

In BFG Country

Such is the energy of Roald Dahl's imagination and his consequent worldwide popularity that perhaps it is not surprising that after his death there was no faltering in his reputation, as sometimes happens with popular writers, temporarily or, sadly, even permanently. In fact, in the period I am writing about it was dramatically reinforced, as 2016 was the centenary of Dahl's birth and also, conveniently, the thirtieth anniversary of the publication of *The BFG*, with the added enhancement of the Spielberg film with Mark Rylance.

The person to address this situation on behalf of the Roald Dahl Literary Estate was no longer the wonderful Amanda Conquy, who, in collaboration with Felicity Dahl, Roald's widow, had been in charge for the previous twenty-five years but, appropriately enough, Luke Kelly, Dahl's grandson, who took up the reins in 2014 and appointed new staff to cope with what was to be a significant increase in Dahl business. He also commissioned a branding exercise, which produced an elaborate style guide and a new logo, prescribed for use in every situation – books, merchandise and so on.

The new regime also considerately made two arrangements that would ease the burden of what they could foresee might be repeated demands on me for interviews and new drawings in the centenary year. One was to commission a long interview with Nicolette Jones for the *Sunday Times*, but which other journals could use, and, based on it, a shorter version for other countries. They also invited me to produce an image of a group of the most familiar characters surrounding the new logo. As is no doubt sometimes the case, what is designed to suit every situation doesn't quite perfectly fit any. At any rate, that was the case here, and I am not sure that the drawing was used more than once in the way that was originally intended.

Sunday Times Magazine cover

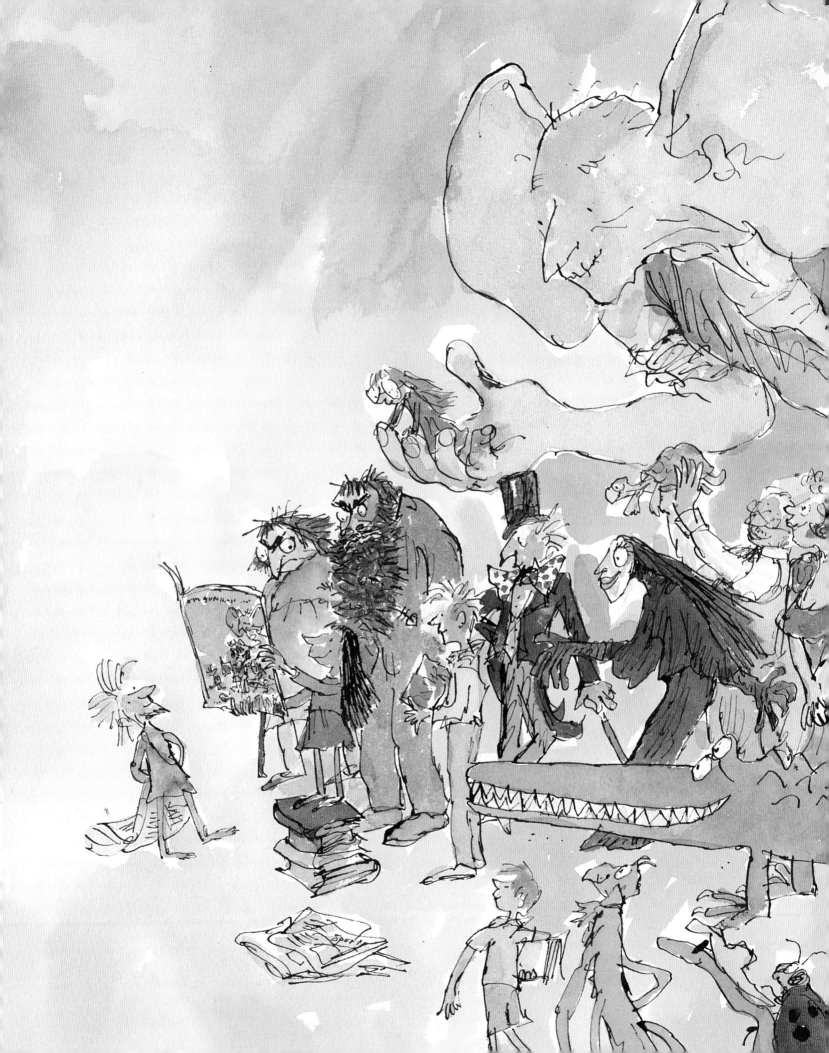

The *Sunday Times Magazine* article provided, almost immediately, a case in point. The editor was interested in having a drawing (perhaps for the first time?) on the cover. One way of doing this would be to bring together elements of existing drawings, but what they would really like would be a picture of Matilda reading the *Sunday Times Magazine*. That was interesting to me, too, since to have everything concentrated on that small element solved the composition of the picture for me, and there was even room for the BFG to crouch down at the back.

I am happy to say that the picture was well received, to the degree that the magazine's editor asked to buy the original. I was sorry to disappoint her, because wherever possible I keep hold of the originals of my published work, so we produced a limited-edition facsimile print, which, by way of compensation, meant that a number of members of the editorial team could have one too.

I suppose it was in the nature of things that there should be other anomalies and that I should feel sometimes that extra contributions were either necessary or attractive or both. An invitation, for instance, came from an issue of a Welsh magazine which had as its subject Roald Dahl's youth in Cardiff and his attendance at the Llandaff Cathedral School, which gave me the opportunity to do a drawing of the young Roald meeting his older self.

Cover for Wales of the Unexpected

A rather different situation occurred with the publication of a limited edition of *The BFG* to be sold exclusively by Waterstones and including all the original and hitherto mostly unseen illustrations from the first version of *The BFG*. I can probably explain this best simply by reproducing the introduction that I wrote to the book:

> It's almost forty years ago now that Tom Maschler, my editor at Jonathan Cape, invited me to make some sample drawings for a new story by Roald Dahl, *The Enormous Crocodile*. According to Donald Sturrock, in his biography of Dahl, the idea originally came from Gina Pollinger, the wife of Murray Pollinger, Dahl's agent, and who also worked in children's publishing. However as Tom had already commissioned me to illustrate the Uncle books by J.P. Martin, and seen into print the first picture book that I had written myself – *Patrick* – perhaps he would not have needed a great deal of prompting.
>
> Roald Dahl had recently moved to Jonathan Cape as his publisher, and it may be that Maschler had suggested to him that he might write the words for a picture-story book. At any rate, my sample was accepted, and *The Enormous Crocodile* duly appeared.
>
> At that time I had no idea that this was the first step in a collaboration that has continued, in various ways, to the present day.

The BFG, Waterstones limited edition cover

Nevertheless *The Enormous Crocodile* was followed by *The Twits*, not a picture book and originally illustrated in black and white, but full of the depiction of energetic and anarchic activity. And then Tom Maschler sent me the manuscript of *The BFG*. This was a different sort of book, much longer, much more a novel for children; so that I wasn't surprised when I was asked to supply (for what was quite a modest fee, even for those days) a dozen full-page illustrations. On this occasion, I gave myself to understand, the words were doing all the work.

The drawings were done, approved by our author, and the text was set and at the printers, when I received a phone call. 'He's not happy.' Nobody wanted Roald to be unhappy, and a solution presented itself. There was a space at the head of each chapter — there were twenty or so of them — and a drawing could be inserted there without having to change anything else. My recollection is that I did the drawings over the weekend, rather enjoying the urgency and curiosity of the challenge, and, having delivered them, sat back with a certain sense of achievement. The next day the phone rang again. 'He's still not happy.'

It was only recently, reading Donald Sturrock's biography, that I discovered that Roald's initial surmise was that, not being offered a royalty, I hadn't tried very hard; and that when it became apparent that in fact I had supplied what was asked of me, his disapproval had been redirected on to our editor. Dahl's view, expressed in his letter to Maschler, was that a novel for children should be properly and extensively illustrated — a view delightful to me but not shared by every author. To achieve that result we had to go back to the beginning and start again. Roald produced a list of the moments he felt he would like illustrated, and, most importantly, he started talking directly to me — and not, as previously, in the editor's office, but at his home. It was the first of many such meetings in the years that followed.

Looking at the existing drawings Roald had come to feel that the costume he had originally described for the BFG, of boots and an apron, was awkward and unhelpful, so that it was at Gipsy House in Great Missenden that we sat around the table and discussed what the BFG should wear. I have already had occasion to recount the sequel. We came near to deciding everything except what the BFG should wear on his feet; but a day or two after my return home I received in the post a large, oddly shaped, brown paper parcel tied with string. Inside was one of Roald's own Norwegian sandals; I don't have to describe them because they are what the BFG is wearing in the illustrations. (You can see the sandal itself if you go to the Roald Dahl Museum in Great Missenden.)

The BFG

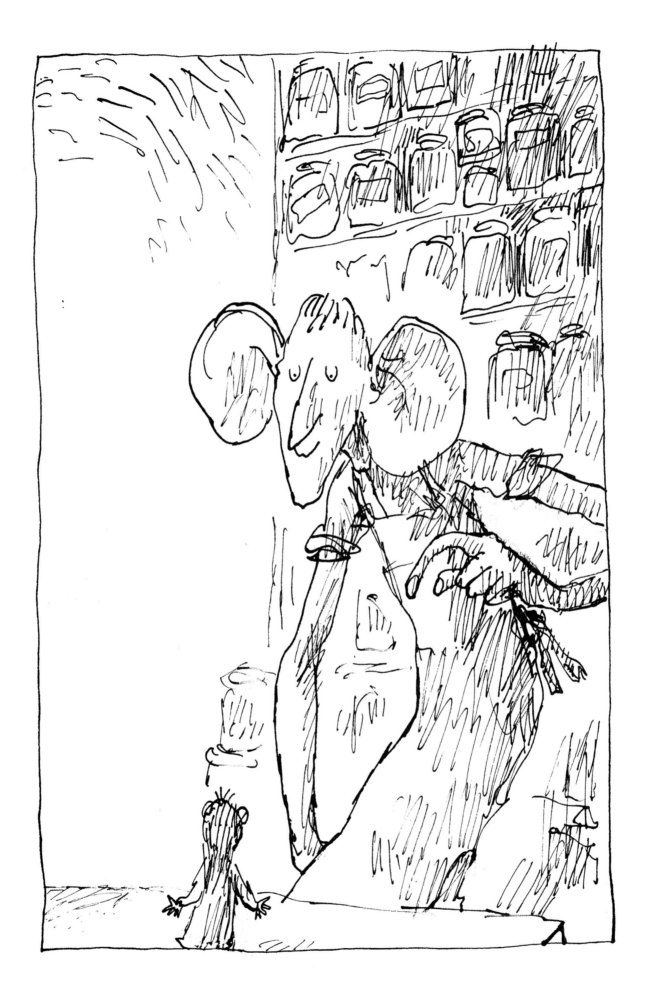

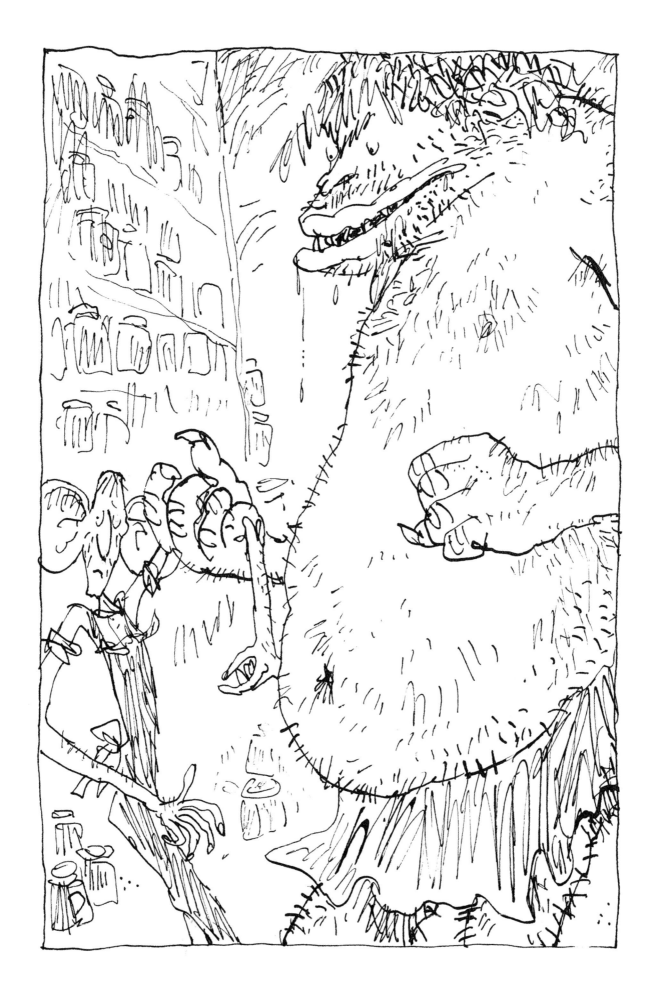

But the sandal did not merely solve the footwear problem – it was one of the various elements in my growing sense of the relationship between the big friendly giant and the little girl (the only character in Dahl's books who has the name of a member of his family) and its importance for Dahl. When I started the first set of BFG drawings – the ones which for the first time you see here – I made use of a lighter line, a nib that could supply hatching and delineate the details of the reality in this extraordinary fantasy. Apart from any other considerations, I would not have wanted to set about re-illustrating this whole book in exactly the same technique – but there were in any case other considerations that made me want to modify the way of drawing. The first BFG had a rather clown-like face, and something of that is in his character, but I needed a more natural description in order to express the variety of feelings and concern in relation to Sophie. The second set of drawings are even nearer to the reality; there is, I hope, a sense of light falling on a three-dimensional world about us; scenes where we might have been present.

And so the first suite of drawings was set aside, and I began a second cooking, which I hope gives an even more satisfying flavour and, to abandon the kitchen analogy, is closer to the essential meaning of Roald Dahl's masterpiece. Set aside, but set aside safely; and looking at the drawings again now, I confess to feeling a certain affection for them. As well as reminding me of that moment, they have in them, I hope, some of that swiftness and sharpness of movement that is one of the aspects of drawing that appeals to me; so that I hope there may be some intrinsic pleasure in looking at them here.

I was delighted with the Penguin designer's ingenuity in making a silhouette from the original proposal for a coloured book jacket against a night sky, somehow enigmatically suggesting the hidden nature of the drawings inside.

Some of these drawings I was pleased to include in an exhibition in the South Gallery of the House of Illustration, which we called *The BFG in Pictures*. Its purpose was to give examples of the various ways in which I had, at one time or another, depicted Dahl's extraordinary character. There were coloured versions of the drawing which had been produced for an Australian magazine and later incorporated in *The Roald Dahl Treasury*, a silhouette to be embossed on the cover of the Folio Society edition, and, I suppose of particular interest to me, the drawing of the BFG on his first appearance in Dahl's writing in the pages of *Danny the Champion of the World*. This drawing curiously came after all the others when I was invited to do new illustrations for the book.

Throughout 2016, the Roald Dahl centenary year, there were, not surprisingly, various other calls for the appearance of the BFG. The House of Illustration enterprisingly came to an agreement with the management of St Pancras Station to do tall banners of the BFG to see people off on Eurostar, and as part of that exercise I spent one beautifully sunny morning at a table drawing in the midst of St Pancras station alongside the memorable statue of John Betjeman.

Aqua Shard, the restaurant on the 31st floor of the Shard

Top left, and bottom: Roald Dahl centenary logo. Top right: The BFG Folio Society edition

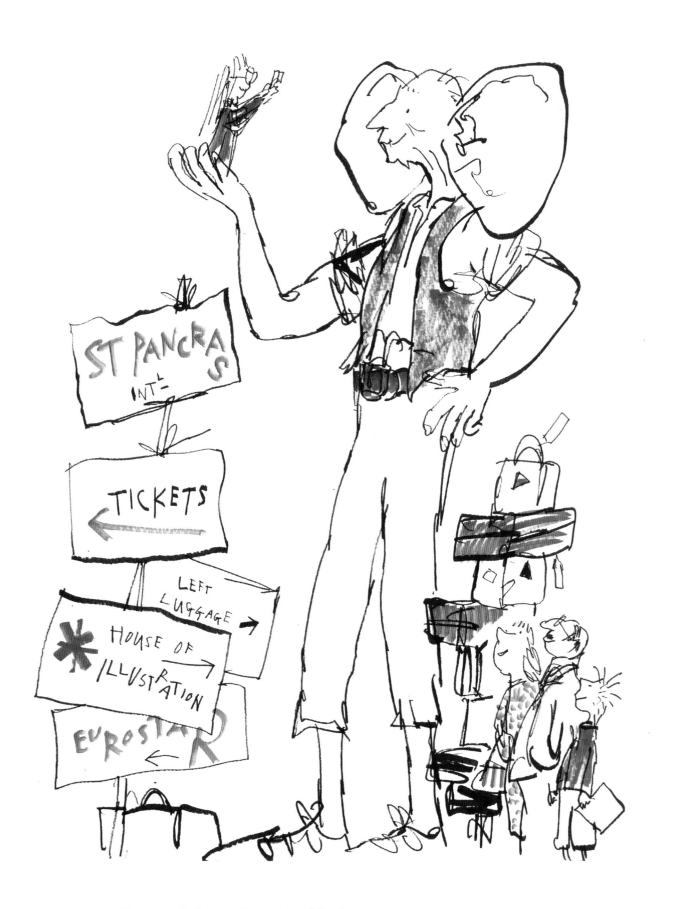

Drawn on St Pancras International Station

Two other appearances of the BFG could not have been more different. I was sent, for my comment, the proposed design for Waterstones logo on their website. The elements from the books that they had found to place alongside each other unfortunately were quite difficult to see at that scale and I proposed an alternative: the famous ears provided a useful solution, this time being filled, appropriately with books.

It was in June of 2016 that I received a letter from Jonathan Marsden, the Director of the Royal Collections Trust. Each year while the Queen is away in Balmoral for the summer, the public is invited to make a comprehensive tour of Buckingham Palace. A tented pavilion is erected along the rear façade, looking out on to the palace gardens. Would I like to do a drawing of the BFG? Perhaps, as it might be, helping to hold up the pavilion? This seemed very appropriate, as an important part of the book takes place in Buckingham Palace, with the BFG and Sophie meeting with the Queen herself. I pointed out, however, that as the pavilion was only to be some 14 or 15 feet in height, it would have to be a rather small version of our hero. That led me to think of another solution: if he were sitting down he could comfortably fill the wall and perhaps for the first time actually be depicted at life size. I also thought that it might be nice if he were to hold out his hand at a level where a child could sit on it. Needless to say, I would not have been able to bring any of this about without the collaboration of Alexis Burgess. He was the person who knew how to get my drawing enlarged to the size of the wall, and to construct a secure and unobtrusive seat. In striking contrast with much work for publishing, where your drawings go off to reappear in proof several months later and in book form even later than that, this task had to be completed within days, as the first visitors would be arriving in the latter part of July.

The centenary year also produced another work for a public space. Aqua Shard, the restaurant on the thirty-first floor of the Shard, had a plan for teatime with Roald Dahl's characters. They were able to use the illustrations from the books to appear in all their diversity on plates and cups and other ceramics, and very large on the windows of the restaurant. What I was called on to supply was a picture of the Great Glass Elevator, to appear to be passing the windows outside, with Danny and Willy Wonka and Grandpa Joe looking in on us. I also had to supply plentiful 'Whooosh' to help it into the air.

Roald Dahl centenary logo for Waterstones

Something rather different from this was involved with the drawings that I did for Roald Dahl's Marvellous Children's Charity. It has two presidents: one is very active, Felicity Dahl, and the other, who is me, does very little except when called on to draw something, as on the two occasions that I would like to describe here.

At Mrs Dahl's invitation, the rose grower David Austin had developed a new rose to bear Roald Dahl's name. Its peach-like colour suggested an affinity with *James and the Giant Peach* and I was called upon to draw that extraordinary group of characters once again, with a bunch of these beautiful new roses amongst them – a picture that made its first appearance at the Chelsea Flower Show, where the rose immediately won a 'Highly Recommended' award.

Celebration of David Austin's Roald Dahl rose Overleaf: The BFG at Buckingham Palace

Another unusual venture was a series of fifty Dream Jars (inspired by *The BFG*) which appeared in various sites across London and Birmingham, Cardiff, Glasgow and Cheshire, real jars of about two and a half feet in height, each containing a three-dimensional creation of the dream of some well-known celebrity. When I was asked to contribute, it seemed appropriate for me to provide drawings rather than hand over the creation of a three-dimensional dream to someone else. So my dream was that I could fly, and three separate pictures found me encountering a Roly-Poly Bird, Helicopters and a giant peach – three Dahl airborne moments.

Dream Jar drawings

Roald Dahl centenary portraits. From left to right: Sophie, Mrs Twit, Mr Twit

The two final projects of the year were also striking in contrast to each other. Some years previously I had had the idea of producing a set of portraits of the best-known Dahl characters, but there seemed to be no appropriate moment for them to be attached to; now, in the centenary year, they made sense. There were ten pictures, and in the explanatory paragraph that accompanied them I referred to the characters as though they were real and had been invited to sit for their portrait. I added that one couple had refused to appear together, and that another clearly disapproved of the whole business.

I had to make the pictures as little like illustrations as possible, but rather as formal portraits where the sitter is posed and aware of the situation. When completed the portraits were framed as a set and went on show at the British Library, after which they set off on a tour of the libraries of various British towns and cities.

The Grand High Witch

George and his Marvellous Medicine

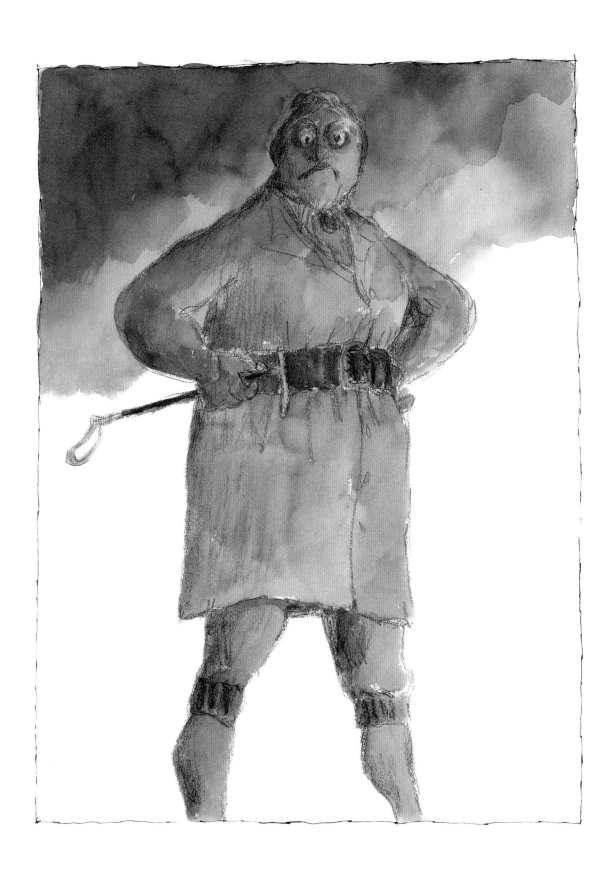

Miss Trunchbull

If the portraits were as formal as I could make them, the next set of drawings were as spontaneous as I could possibly imagine. I had agreed to do some drawings to camera, in my studio, for a new documentary television programme about Roald Dahl's life. What I hadn't expected was that the director, Andrew Thompson, had the original idea of getting me to draw incidents that had happened before I met Roald and which, as I protested, I had only heard about. For him, that was no deterrent – 'No, just go on and draw it'. Whatever the accuracy, it was at least an ingenious visual way of presenting something of which there was no documentary evidence. So there were instant versions of incidents in Africa, of Dahl meeting C.S. Forester, and of President Roosevelt in his personal wagon. And perhaps they did, after all, have an odd sort of authenticity.

Roald Dahl BBC documentary

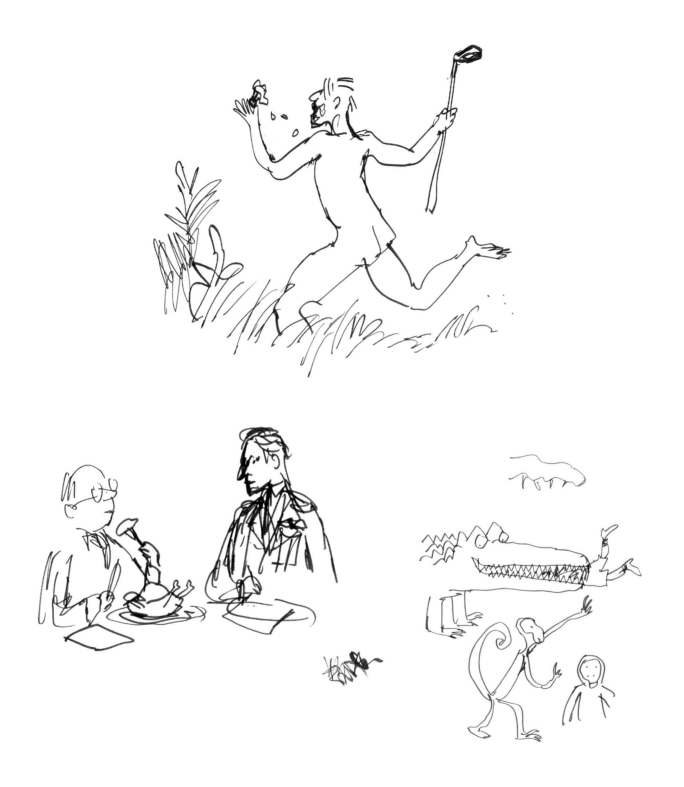

The Dark Forest

The previous section was about my old acquaintances from the world of Dahl, revisited and reimagined in a variety of sizes, shapes and situations. This one is also about the illustration of a Roald Dahl children's book, but the experience was rather special for me, which is why I feel that it deserves to be treated separately.

The last two of Roald's books that were illustrated in his lifetime were *Esio Trot* and *The Minpins*. I worked on the first, while at the same time the other was commissioned from Patrick Benson. Patrick Benson is an artist I know and admire; his book was a large format and in colour, and he made something wonderful of it, with dramatic and detailed views of fire and smoke and of forest and clouds.

Early in 2015, twenty-five years later, Dominic Gregory of the Roald Dahl Literary Estate came to talk to me about a possible re-illustration of the book. This was not because of any dissatisfaction with the existing book, but Penguin Books had, over time, become aware that there was no way that the existing version could appear except in the original format; the scale and detail of the pictures wouldn't allow it. What the publishers needed was a book that could sit alongside the other Dahl titles, go into paperback and be stuffed into pockets. Would I take this on?

I was reassured to know that the original version was to be kept in print. Although my text was to be identical it was going to be called *Billy and the Minpins*, the alternative title that appears in Roald's handwriting on the typewritten manuscript. The new book, in small format, would have about 120 pages, the words would run to nearly sixty pages, so that virtually half the space was available for illustration.

I have said 'the new book', and to me it did seem very like a new book. Forty years after I first read the manuscript of *The Enormous Crocodile* I was setting about a story that, excitingly, I felt I didn't really know. And now words and pictures ran very closely together, hand in hand. The text was newly divided into chapters; I was allowed to invent the titles but, even more interestingly, it meant I had to cut up the printed text (in the old-fashioned way) and make a complete layout of the book: Billy's increasing panic, for instance, as he is pursued by the frightening Gruncher – the sequence of expressions on his face and the quantity of smoke is followed over several pages.

The accompanying revelation to me was that Billy stopped being any small boy in a frightening situation, and became more of an individual – another of the company of Roald Dahl's young heroes and heroines. I wanted him to look distinctive and distinguishable from the others and I still have the sketchbook in which I started to imagine what he looked like – rather small, skinny and agile. The standing-up hair I hoped would suggest something of the liveliness and rebelliousness in his nature.

And then I was able to get really close to the Minpins themselves. Dahl mentions their having old-fashioned costumes, in brown and black, of two or three hundred years ago, and I suppose my Minpins are in a sort of confused seventeenth-century attire. They are also described as being present in thousands; something easier for a writer than an illustrator. I hope I may be forgiven for my Minpins being merely numerous. What I most wanted to do was to get into the close-ups – to show the variety of their shapes and sizes, and to work as many possible permutations as my pen could think of.

My feeling, as I approached the end of my work on the drawings, was that there was something very special about the book – almost in some way light-hearted. Billy's insouciance contributes to this; the threat of the Gruncher isn't personal, and there is no threatening individual. And then, once the swan appears, the mood changes dramatically and Billy finds himself in a series of extraordinary experiences, flying into the clouds, through the night, and into the bowels of the earth. Dahl was a storyteller, not a poet, but he was also a flyer, and what we have here is, surely, an expression of his own poetic vision.

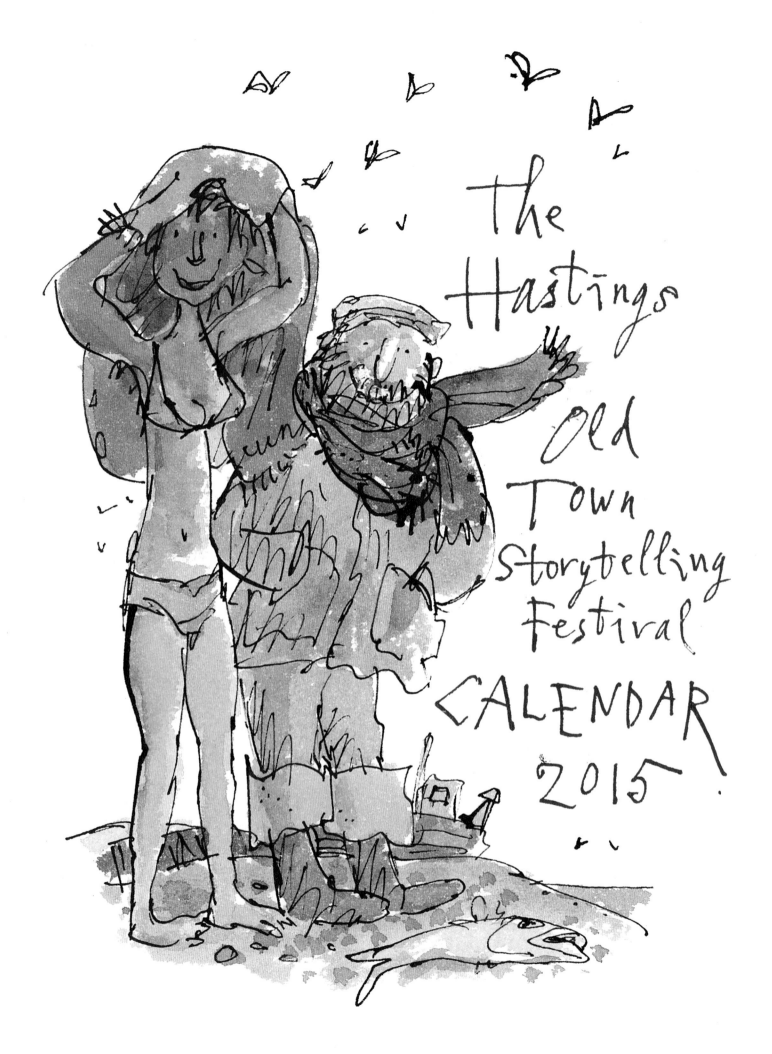

The Hastings
Old
Town
Storytelling
Festival
CALENDAR
2015

Hastings I

I suppose it is an accident of geography that Hastings Old Town is comfortable in its own small valley, and has, with the exception of a main road insensitively driven through it in the post-war period, kept its own identity and character. I have owned an ancient house there for about forty years. I have always found the Old Town interesting, but a few years ago it became interesting in ways that I could not have foreseen. The story begins with Dick Edwards, chair of the local Residents Association and initiator of the Hastings Storytelling Festival, which he enlisted me to support.

I produced some drawings especially for it. To begin with, two for a Storytelling Festival calendar. The first version showed a holidaymaker and a fisherman; the second, when the festival received an Arts Council grant, showed a small group of young people of assorted ethnicity listening to the fisherman, who on this occasion is the person doing the storytelling.

The seafront at Hastings that faces onto the fishing beach has the rather strange name of Rock-a-Nore, and the next drawing I was asked to do was of a Rockanaurus; he was to be useful in the festival's outreach programme into local schools. This, incidentally, is not the least important part of the festival's activities, which, in addition to telling stories, is very active in promoting literacy and sending writers and artists into local schools.

At the same time as this something extraordinary happened on the Stade behind the fishing beach. The Jerwood Gallery appeared, to a chorus of local protest: extremely well designed and harmonising with the black netsheds which are characteristic of Hastings and, wonderfully for me, at the end of my street. Dick Edwards arranged for me to give a talk at the gallery entitled 'Story

The Hastings Storytelling Festival

in Pictures', and it was then that I met Liz Gilmore, the director, for the first time. She is someone whose perception and skills are impressive, and who has a keen sense of outreach to the local community. She also has a sense of theatre and is ready to organise the photographing of a hundred local residents in the nude on Hastings beach if she feels there is advantage in it for the gallery.

In 2014 Liz asked me to take on a project which we called 'Artists on the Beach'. I chose ten of the artists in the collection, and of each of them I made a portrait which appears in the drawing on an easel on Hastings beach. My drawings were hung together as prints in a room near the entrance to the gallery, each with one or two sentences of informal comment of my own. I hoped it was as if someone had said to the visitor: 'Why don't you go and have a look at …?' At the same time the drawings and comments were brought together in a little book available in the gallery shop. They also prompted two panels – enlarged black-and-white drawings of everyday artists among the fishing boats – which periodically decorate the Jerwood café.

John Bratby

Quentin Blake

ARTISTS ON THE BEACH

A Jerwood Notebook

Edward Burra

Dod Procter

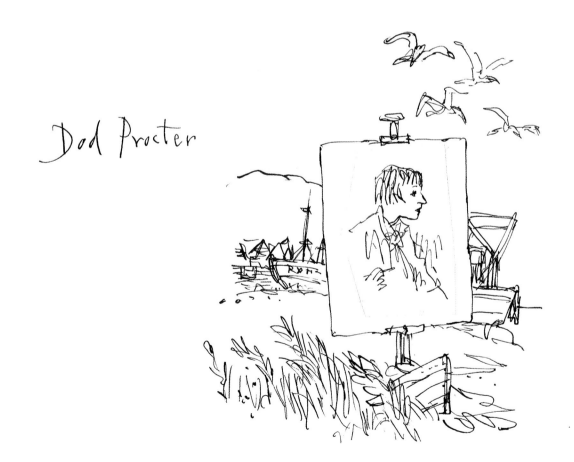

Alfred Wallis

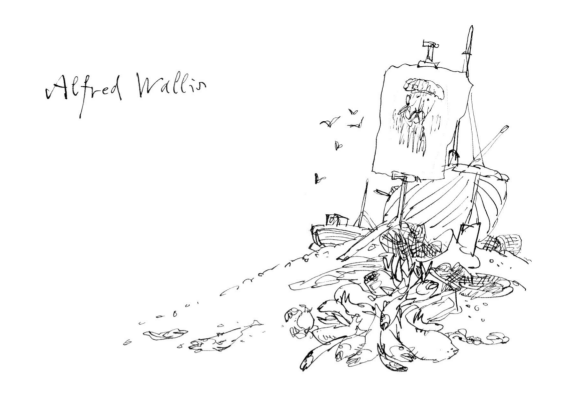

Maggi Hambling

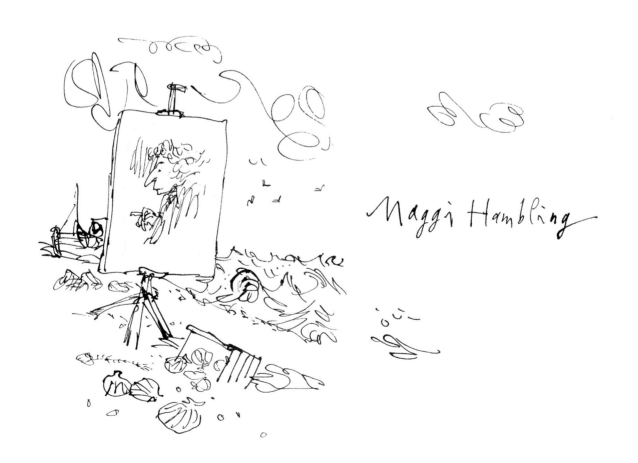

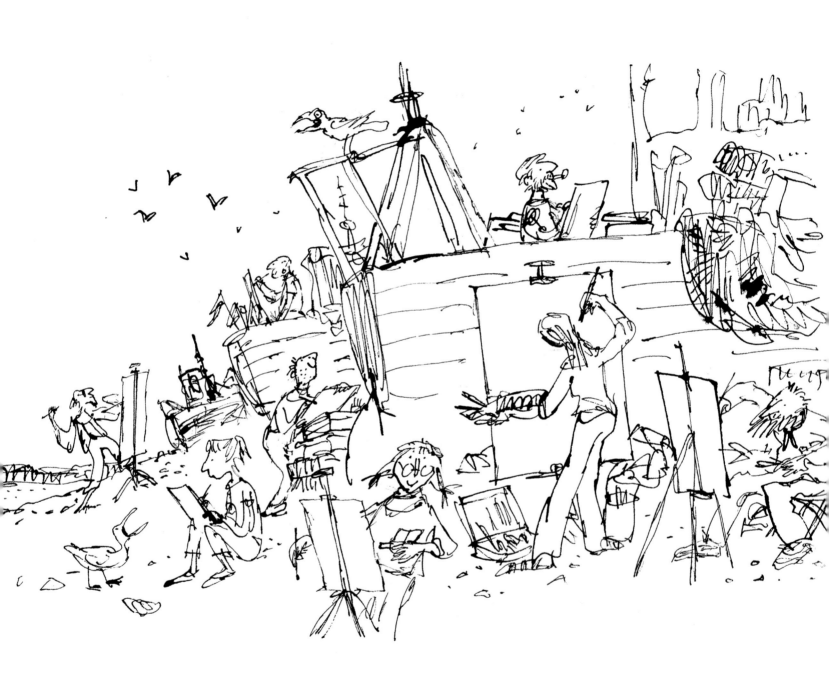

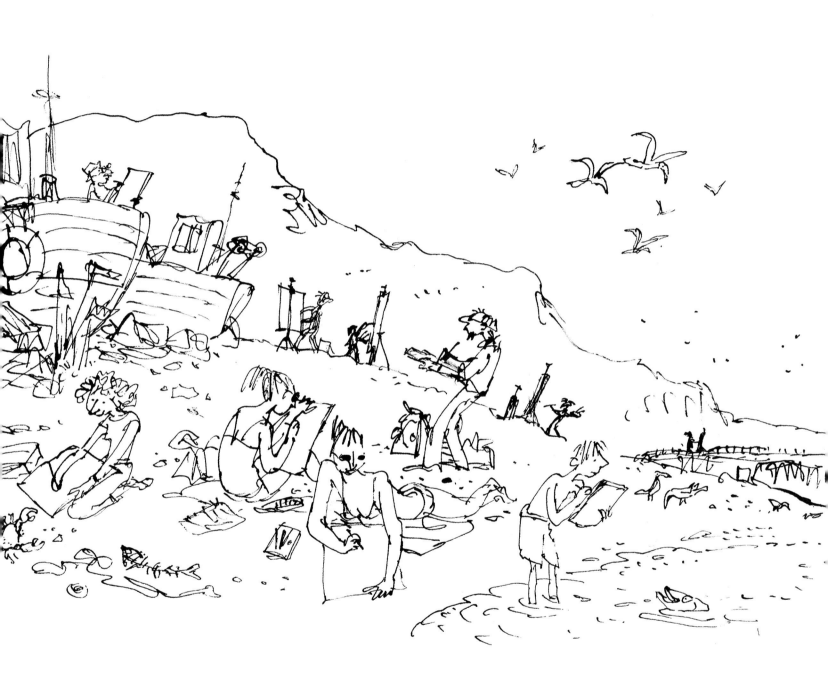

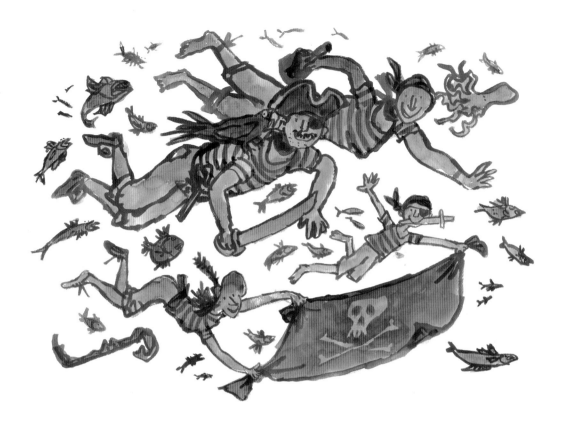

As this venture proved to have the effect we had hoped for, I was invited to invent a sequel. This time it was not the painters in the gallery, but Hastings people themselves who were the subject. I decided to make use of a convention that I had employed previously in a set of hospital pictures – of people fully clothed but nevertheless underwater and accompanied by fish and seaweed. The fish seemed particularly appropriate here, and it was called 'Life Under Water: A Hastings Celebration'. There were twenty-four pictures and of the characters they showed, some were fairly general – ladies returning from the library, schoolchildren on their way home – and others more specific, reflecting Hastings life and occasions: Morris Dancers, Jack in the Green, Pirate Day, the sinister drummers who march through the unlit streets of the Old Town on Guy Fawkes night, as well as the middle-aged bikers who arrive at the weekend.

Life Under Water: A Hastings Celebration

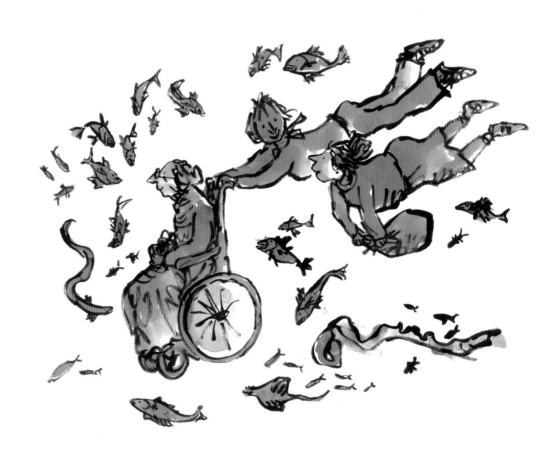

My next Hastings endeavour was not an exhibition but something that would have a more permanent presence. Dick Edwards put me in touch with Valerie Wright, who is responsible for Hastings and other Sussex libraries. The Hastings library building was being refurbished and the junior library, hitherto housed modestly in a nearby street, was to be brought into an attractive space on an upper floor. Some kind of decorative feature seemed to be in order, and Dan Jones of Burgess Design went to look at the site and to establish position and dimensions. We decided on a wall hanging similar to that we had created for the French Institute junior library in South Kensington.

To make it belong particularly to Hastings I wanted to show something of the fishing beach, with a fishing boat in the foreground. Some years ago I did the cover of a brochure for the Bologna Children's Book Fair, where I showed children flying about on their books, and I made use of the idea again here. This time the sky was full of young readers, as well as one or two surprised-looking seagulls. One subsidiary advantage, I realised, of having the children airborne was that if necessary they could be used separately in other inland Sussex libraries where the Hastings fishing boats would be inappropriate. And so to make absolutely sure that there was no question that this was something happening in real life, I gave each child its own heraldic colour. The picture is not real life, but I hope it genuinely says something about the effect of books, especially on young people.

Overleaf: Hastings Junior Library wall hanging 123

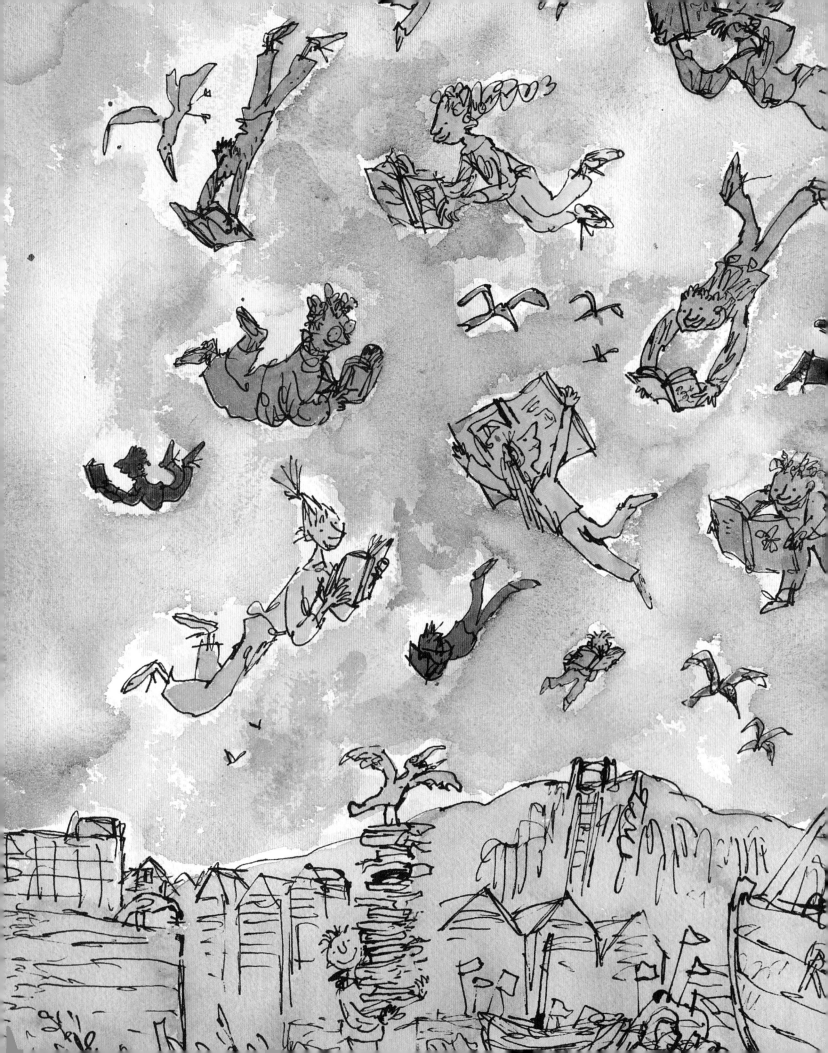

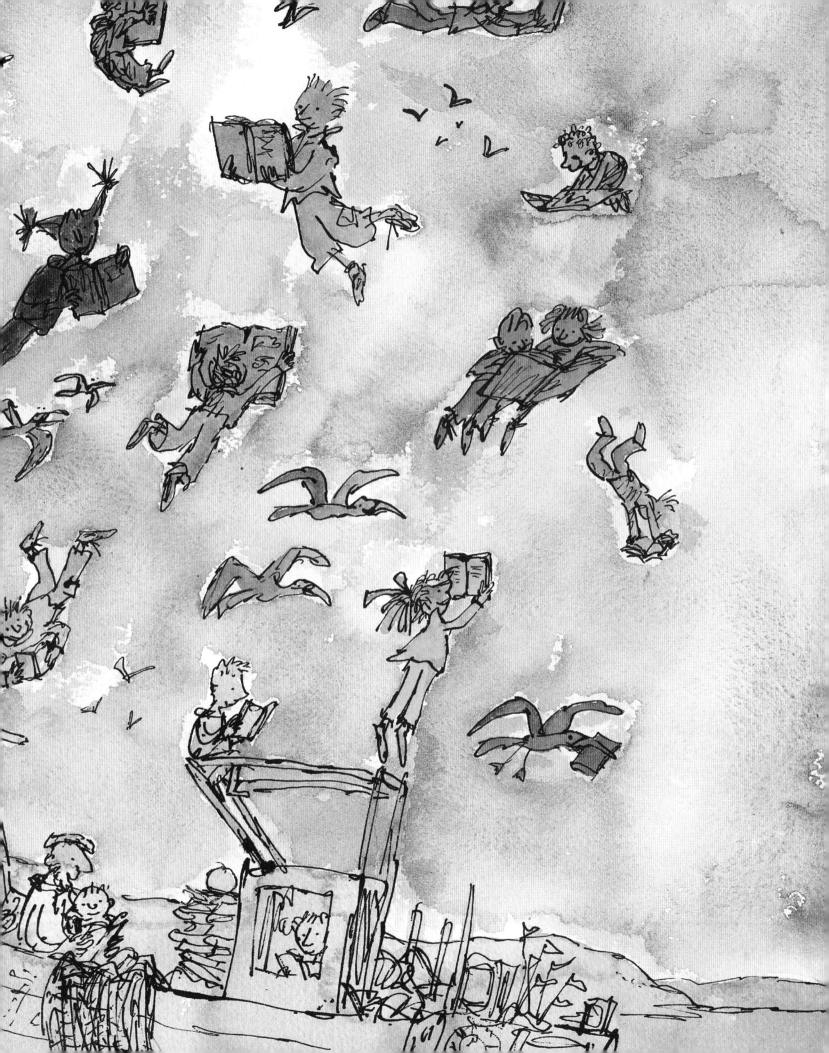

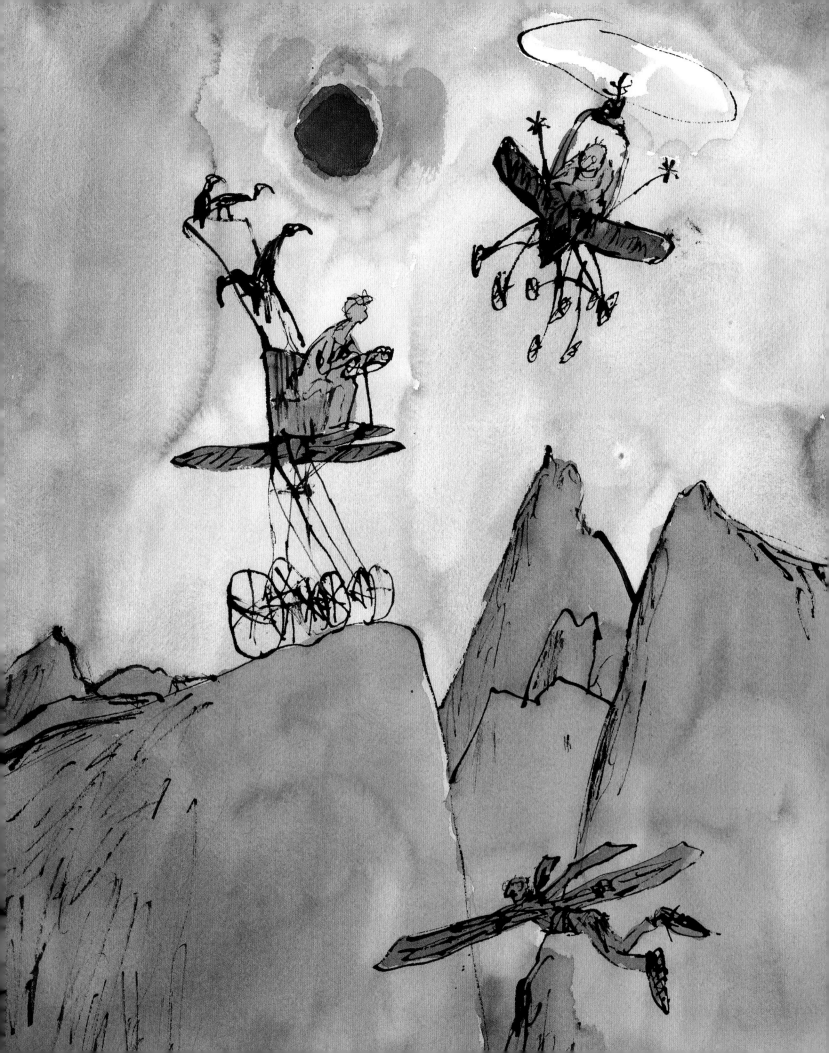

Hastings II

With the Hastings Library wall hanging safely completed, I began to consider the question of what I might do next for Jerwood. Somehow I assumed that another show would be modest, not to compete with its predecessors. I was wrong. Liz Gilmore made me the invitation – actually it seemed more like a command – to do *very big* drawings that would fill the Foreshore Gallery, a handsome space normally used for exhibitions of contemporary oil paintings.

This was of special interest to me, partly because I had never done it before (except once or twice before audiences) and partly because over the past dozen years I have had many drawings enlarged in printing from work done on the desk in the studio. This time I would have to make them huge myself. In the event, not all the drawings were large and there were plenty of small exploratory ones, so that I was using implements ranging from a Berol italic pen to commercial paintbrushes and paint rollers. The most curious was the Rotring ink dispenser. You are supposed to use the tiny nozzle to fill your fountain pen, but if you draw straight from the container you get a fluid spotted line and frequently such quantities of ink that it takes days to dry.

I think I was lucky to find the theme 'The Only Way to Travel'. I chose it partly because I felt everyone could relate to it; but, much more importantly, it gave me the opportunity to fantasise about new and unexpected modes of travel to which probably nobody could relate. I think the choice was also partly prompted by a sequence of drawings that I had over recent years produced for my friend Linda Kitson. We called them 'Vehicles of the Mind' and they were drawn on a variety of sketchbook pages, notebooks, paper napkins. Each was a variation on the same formula: a large, frequently angst-ridden visage, and in a driving seat behind it a fairly relaxed-looking driver – ladies of various ages, or a formal-looking gentleman. I am not really able to explain what they are

about, although they may be in part derivative of other work that I have done for mental health institutions. The game was to vary the elements on each occasion – the degree of comfort or distress, the number of legs or wheels or feet or wings.

Next came the practical problem of how these big drawings were to be done. In my half-timbered Hastings studio I could work on sheets of watercolour paper 4ft × 5ft – the largest I could get up the crooked medieval stairs – laid flat on a table or on the floor. In another studio that I have in London I was once again indebted to Linda, who was able to mount sheets of paper on the walls with gum strip, some as large as 15ft × 10ft. I could start work.

In the drawings there arrived other strange creatures, curious birds with several legs and wheels and a driving seat; aeroplanes with faces; quixotic extrapolations of the mountain bike. I made them up as I went along, almost like a performance. In fact two actually were a performance. A few days before the show opened, when the gallery was cleared of the previous exhibition, two large sheets of paper – about 9ft × 20ft – were mounted on the gallery wall and Liz Gilmore brought in a cherry picker, which, she assured me, she had a licence to drive. With a long brush it is not impossible to reach to the top of a nine-foot piece of paper, but with the cherry picker and the help of a stepladder I found myself near enough opposite to what I was drawing and we were filmed by the gallery's photographer, Tom Thistlethwaite, and a team from the BBC programme *The One Show*.

The Only Way to Travel

130

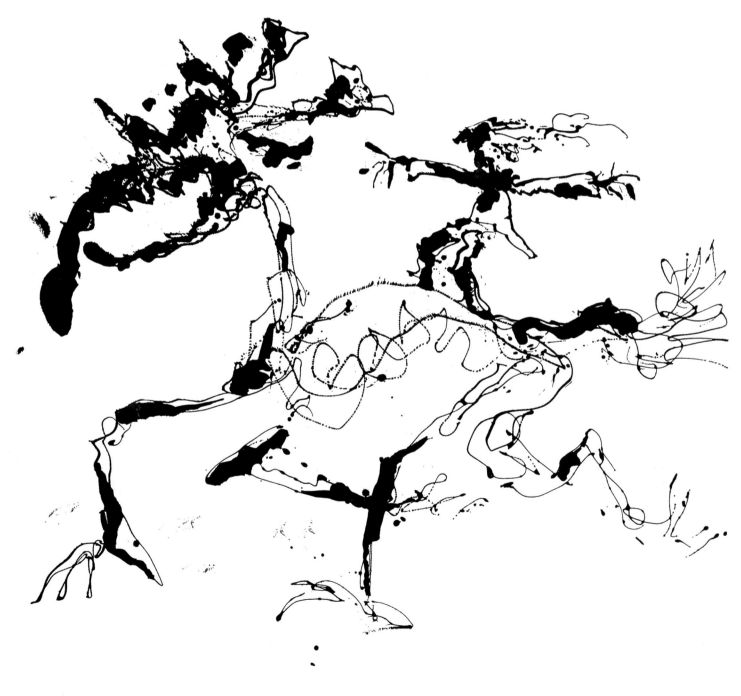

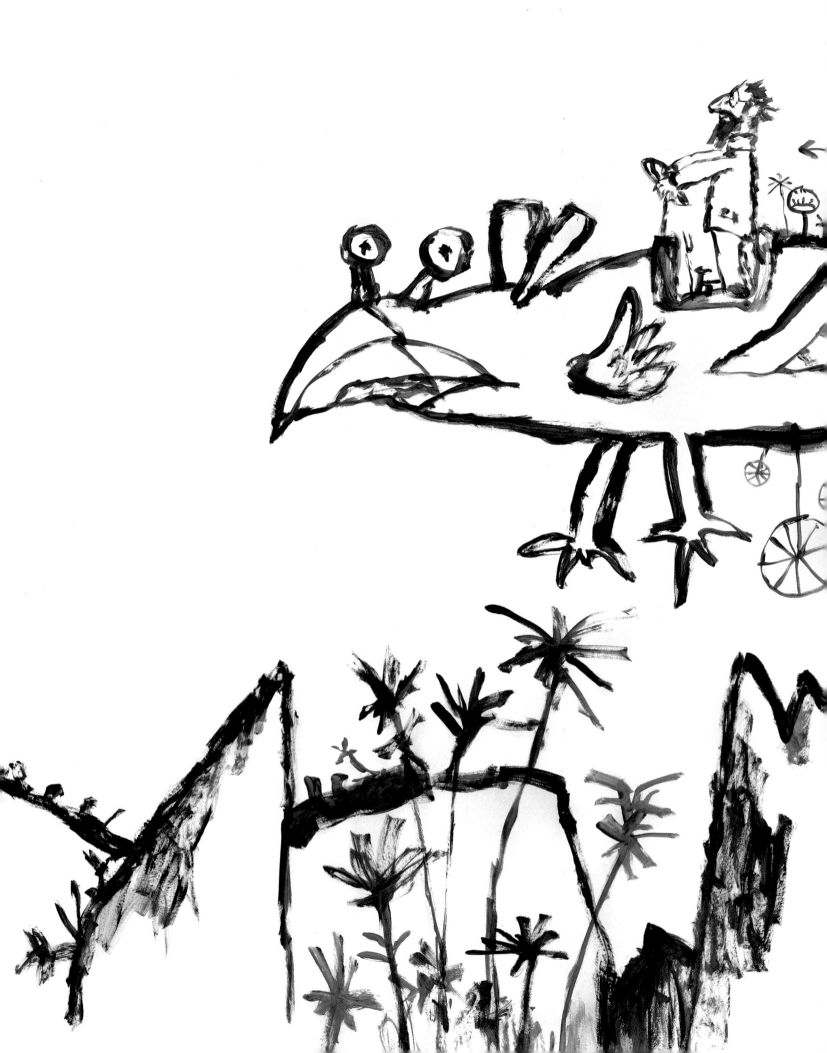

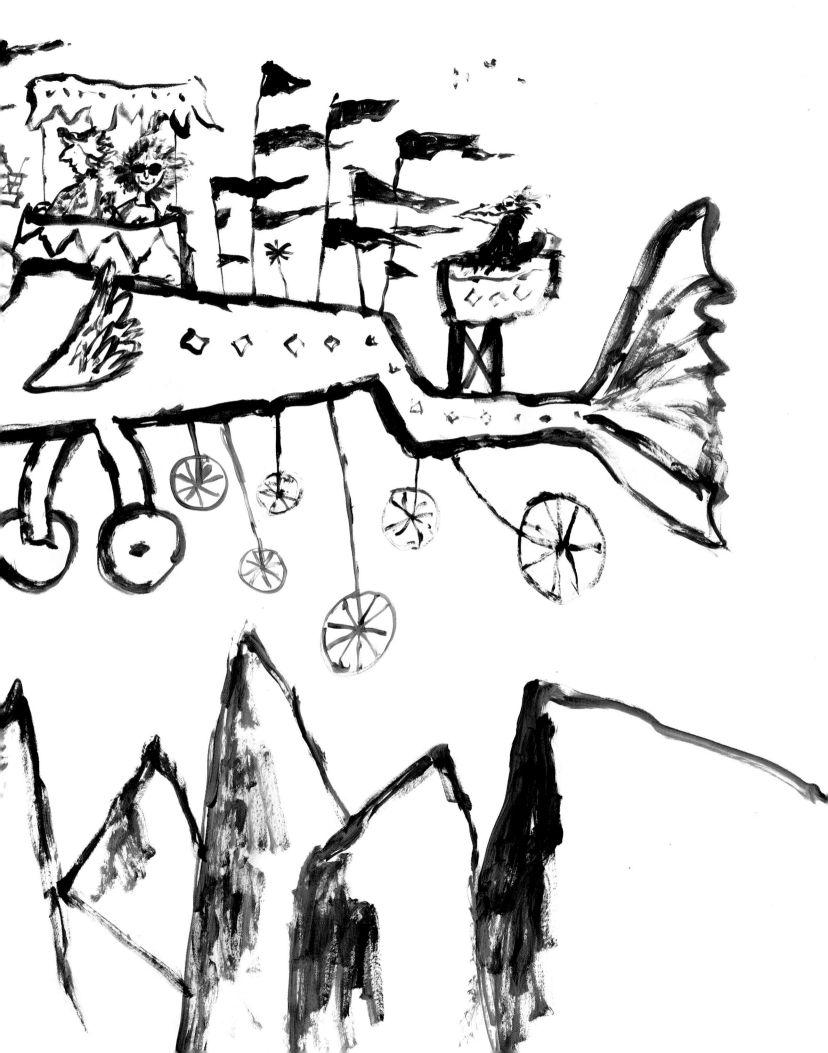

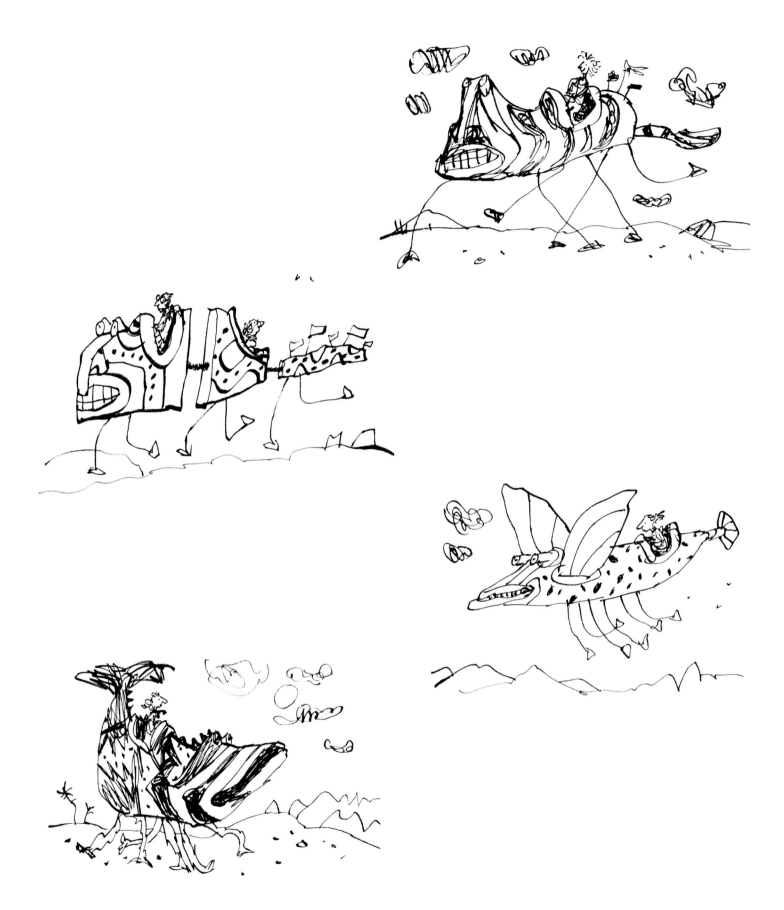

The Only Way to Travel

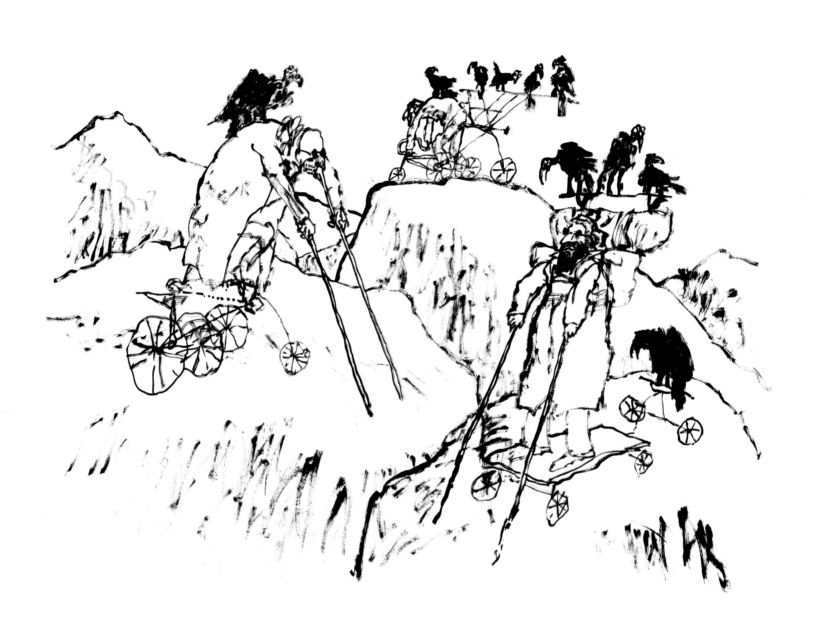

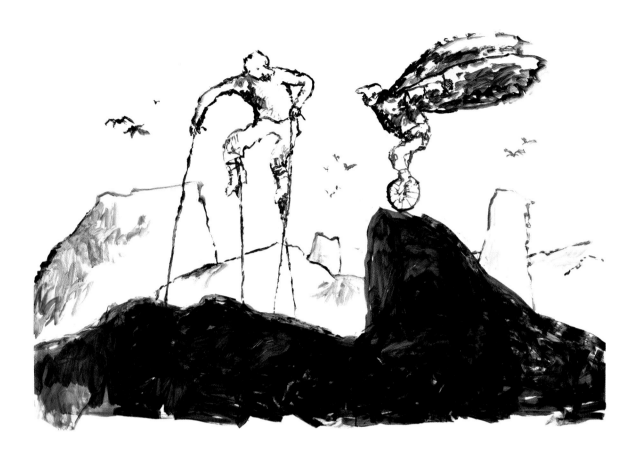

What I was surprised to discover was that my fantasising took me further than I had anticipated. I had not expected, for instance, the men on sticks with their rucksacks and vultures in an unsympathetic landscape. I think it was this development that also prompted me to start a set of watercolours. Having recently completed the illustrations for Russell Hoban's *Riddley Walker*, I tried my new subjects in a similar technique. Drawn with the same deteriorated quills, the whole image was tinted in Payne's Grey watercolour, with the exception of a coloured moon. I showed the first batch of eight to Liz Gilmore, who found them 'poignant and haunting', and that gave me new energy and the number of them soon rose to the twenty-one that eventually appeared, framed, in the exhibition. Two of them move away from metaphor to acknowledge the reality of a different kind of travelling in the present-day world.

We agreed that, although the framed watercolours would not be for sale, the other works could be, if anyone expressed an interest. In the event, such was the interest that, rather to the surprise of us all, the smaller works were all sold in the first weeks of the show, together with a considerable number of the larger ones, and some of those could be replaced by others waiting in the wings. The gallery shared the profits with me, which was especially gratifying in two ways, contributing as it did to the activities of the gallery and at the same time giving me a sense of how the people of Hastings were reacting to the show – perhaps some of whom would not normally have thought of visiting an art gallery. Indeed, one woman confessed that she had never bought a picture before; she worked as a postwoman and 'I think I might have to do some more overtime'. Another reaction came in a letter from a woman who had visited the exhibition with her husband and enjoyed it but, as she said, 'one piece particularly I found quite haunting … it epitomised for me the struggle my husband has had with his disabilities, and especially with the Department of Work and Pensions regarding his

entitlement to benefits'. I hope that in some way it helped; for me it was good to know once again the drawings have a way of speaking to people, and that someone is able to find *their* meaning in an image and its potential metaphor.

For a short while I thought about the possibility of a catalogue for the exhibition, though it hardly seemed appropriate for such a various and shifting scene. It occurred to me finally that the publication more in keeping with the show would be some kind of broadsheet or newspaper – and that, with the help of Burgess Design, is what we produced. There were forty pages in tabloid format and on newsprint, though probably with a slightly superior surface to most dailies, which helped to take the half-tone pictures. The size gave me a chance to show the diversity of the works, and the photographs a sense of the big drawings in position on the wall. I think the fact that these were not 'catalogue pictures' helped to give some air of this being, as Liz Gilmore suggested, another sort of artwork in its own right.

At the end of the show in October 2017, it was those watercolours that I had come to think of as *Moonlight Travellers* which still kept hold of my imagination, and I set about a new sequence with similar subjects and at the same size, but this time in horizontal format. There was now, also, my sense of the openness and enthusiasm of the Jerwood Gallery, so that I was pursuing my own fantasy but with a real prospect of exhibition. There proved to be about thirty drawings in all. When I was some way through, however, and had achieved the twenty I thought I needed, I had an unexpected interlude. Perhaps reacting to the omnipresence of Payne's Grey, I found myself taken with the idea of *Scenes at Twilight*, and in a few days produced about twenty of them, with an assortment of moods and each with a different colour. Some, while acknowledging the twilight moment, were even quite optimistic.

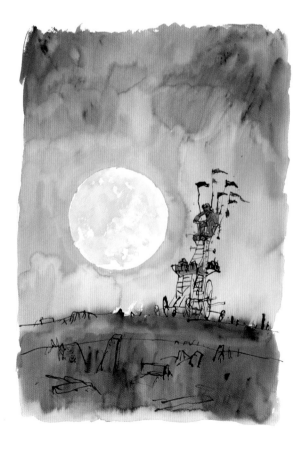
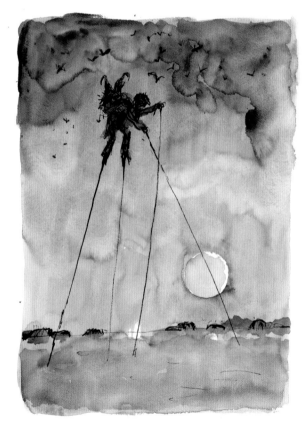

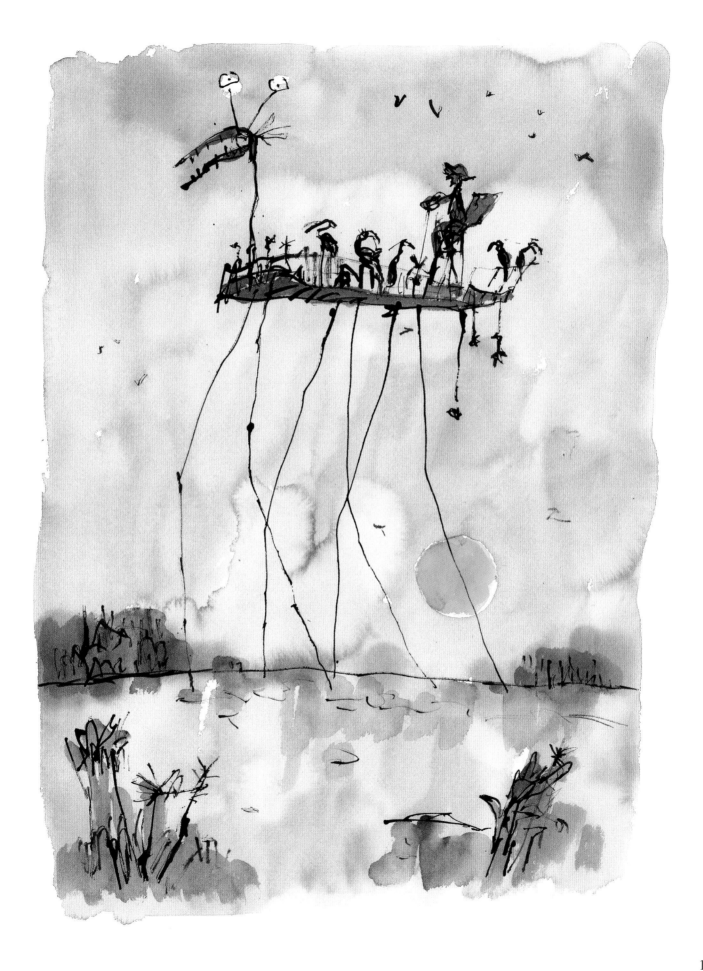

143

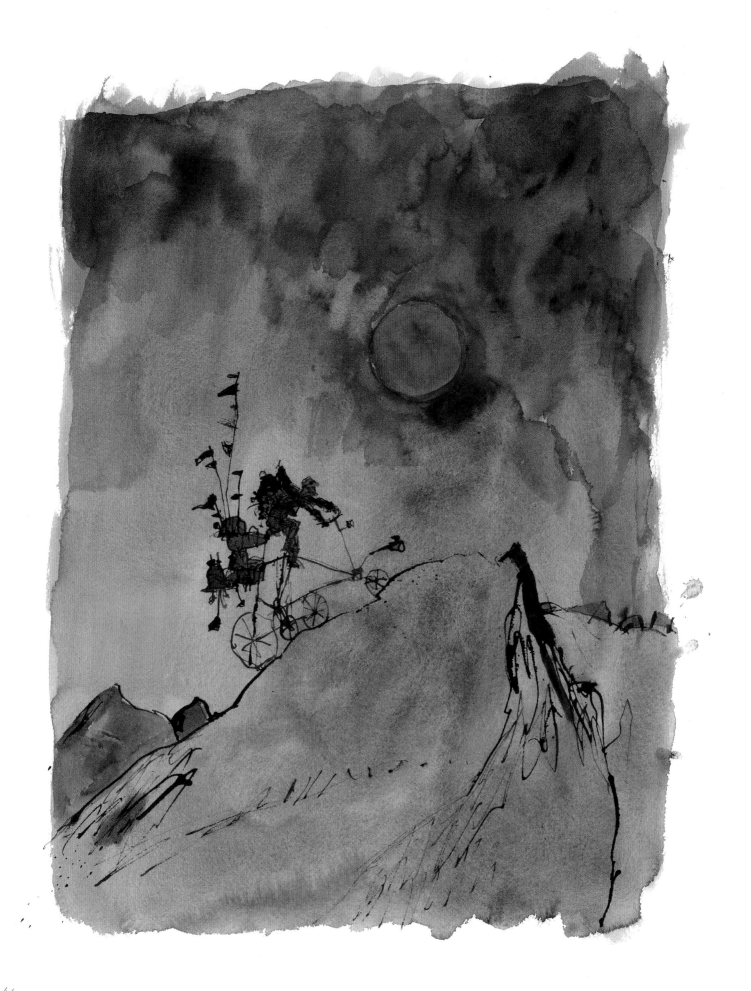

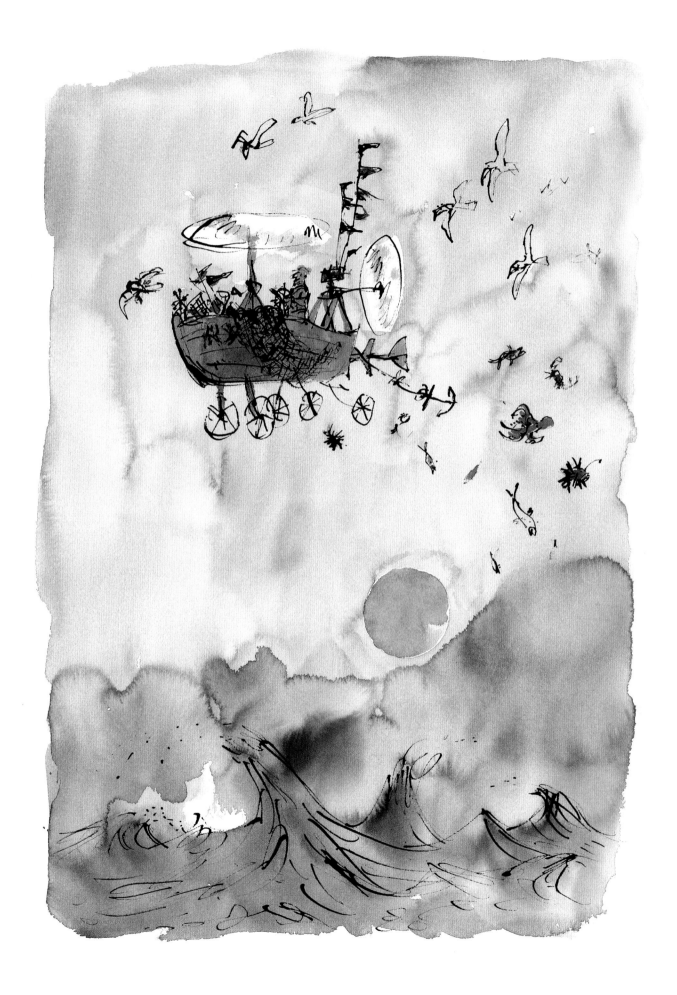

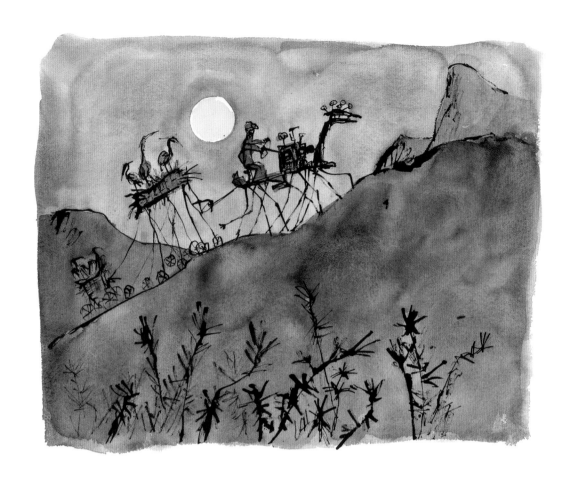

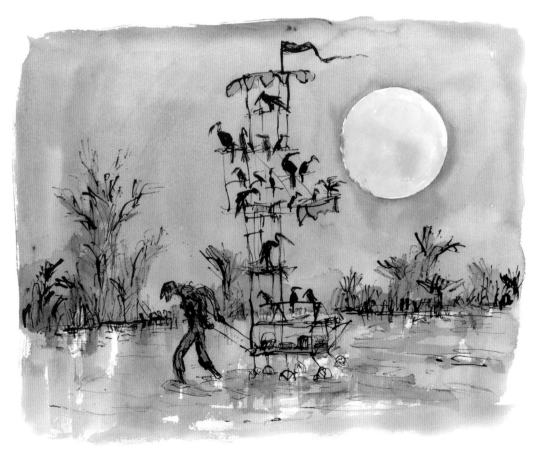

146

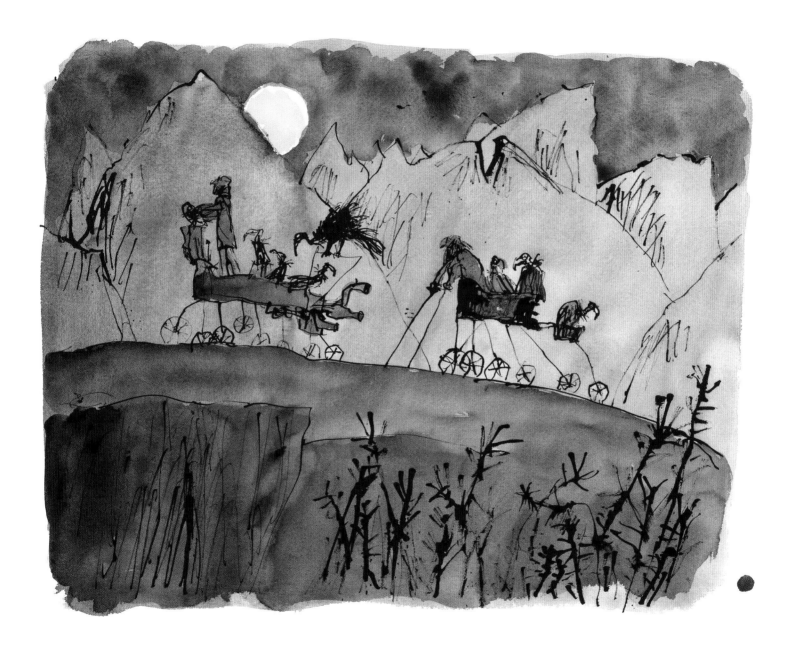

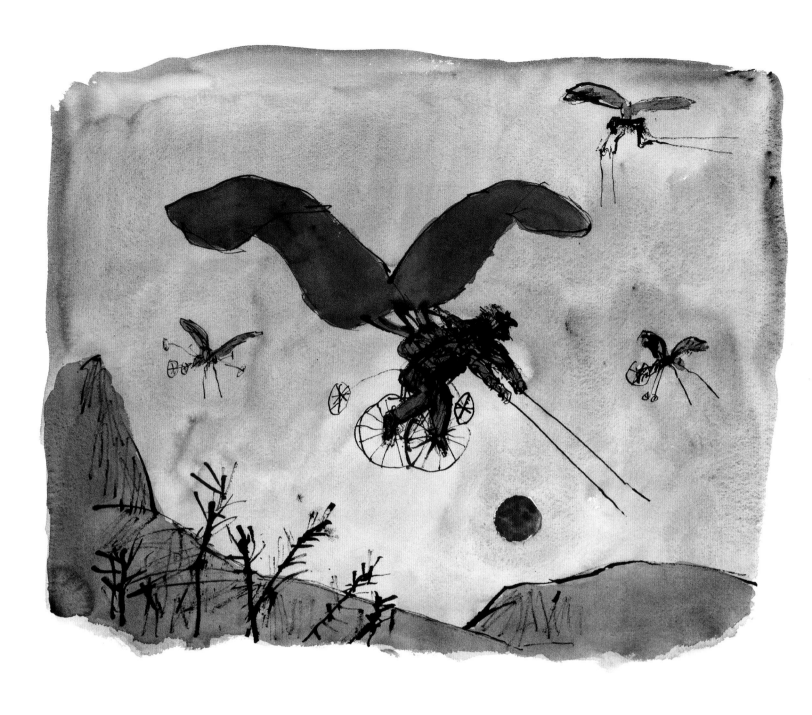

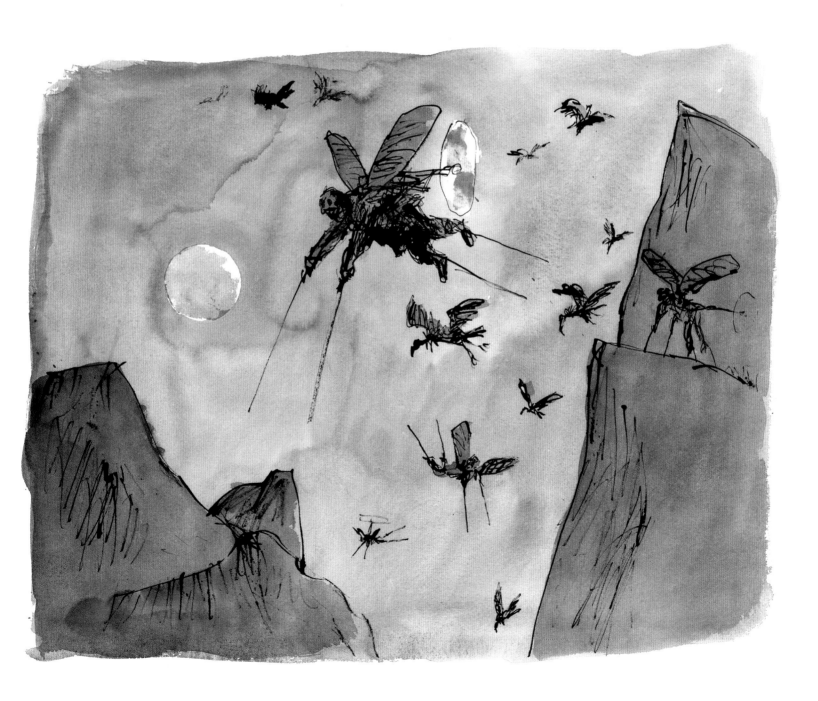

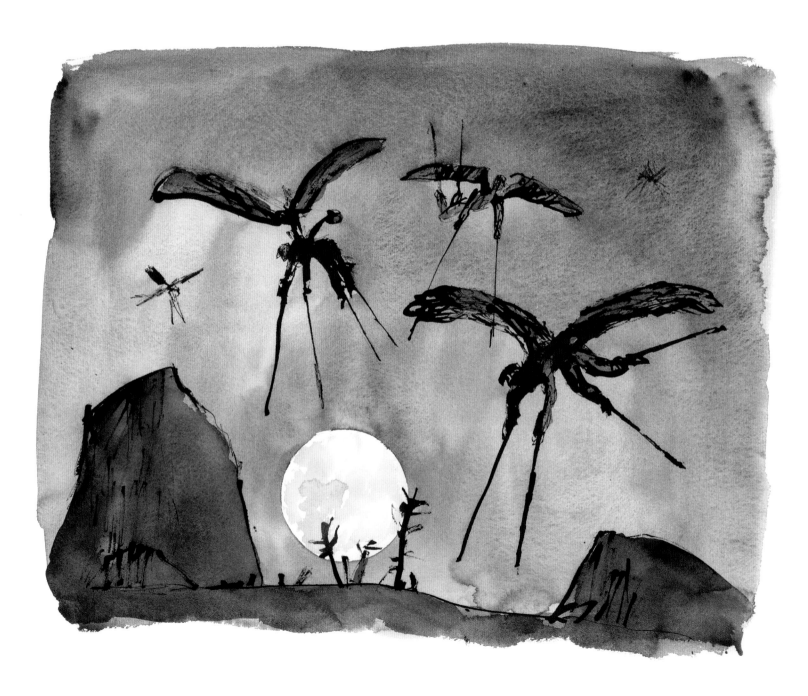

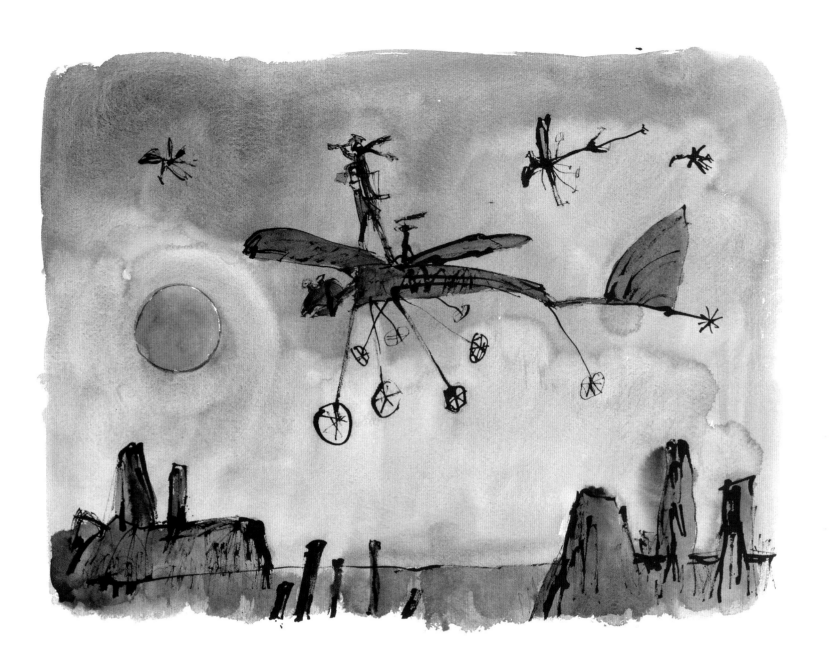

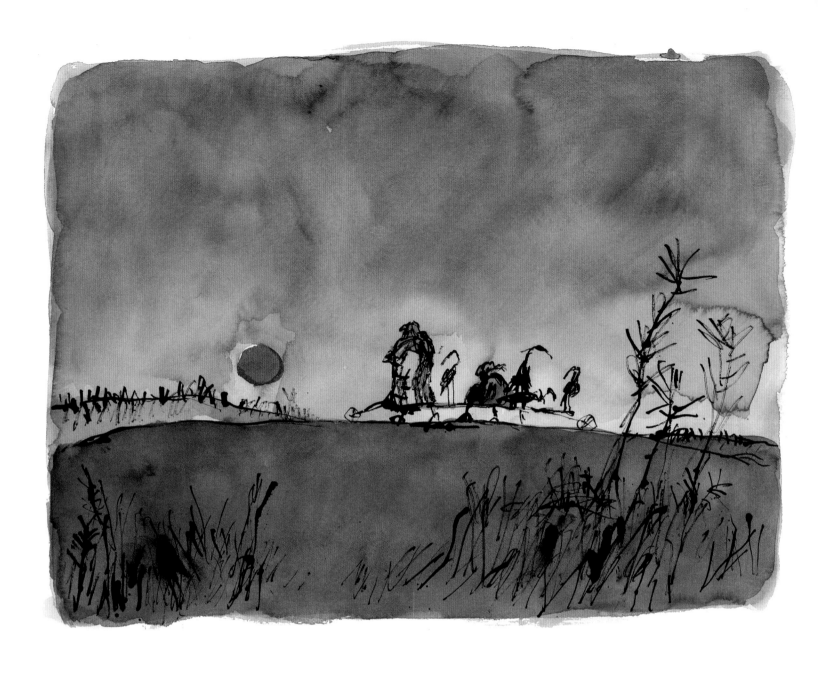

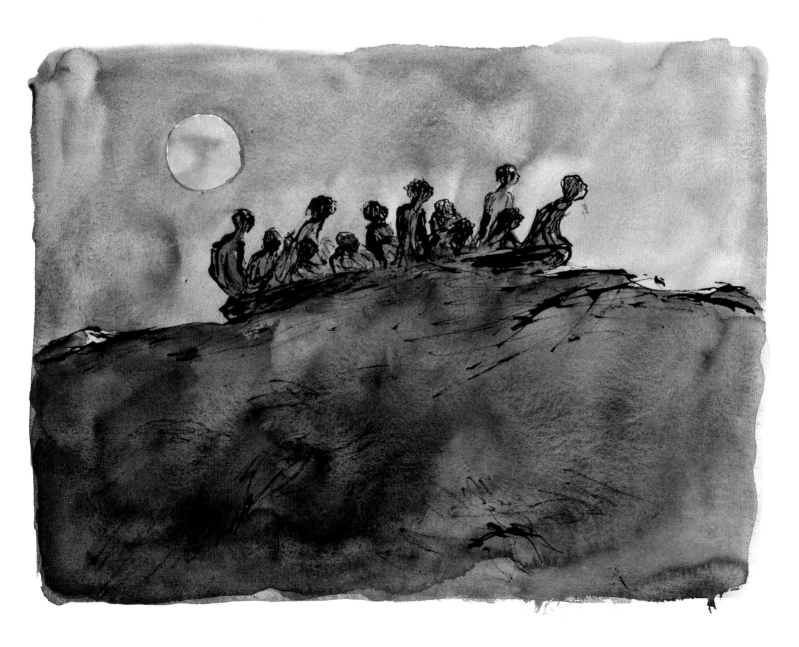

Scenes at Twilight

157

Walking with the Birds

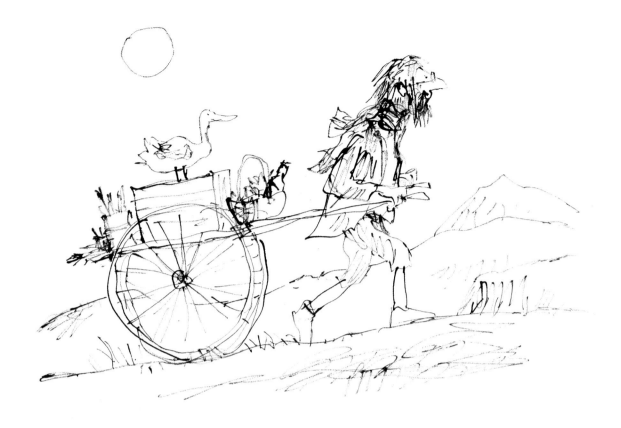

On 1 January 2017, as a result of working relentlessly over the previous two or three years, I started to have a small breakdown, which put me out of action for about six weeks. On 1 January 2018, in a different frame of mind, I got up and drew a picture of a bearded man resolutely setting out in the sunlight with his cart and his duck, and I suppose he was the nearest I have ever got to a New Year Resolution. That day and soon after, I did several other drawings of people walking with birds. I don't think they, even inadvertently, have any freight of meaning, but I hope they are enjoyable to look at.

Liz Gilmore had suggested that when the show of *Moonlight Travellers* and *Scenes at Twilight* came to an end, I might continue to have a presence, so that in one or other of the first four rooms there would always be a small collection of my drawings on some chosen theme: a small bonus for visitors to the main exhibition. My people walking with birds could be one of these. Hats became the next subject that called out for attention, full of possibilities of fantasy. And then after that, what next?

160

The World of Hats

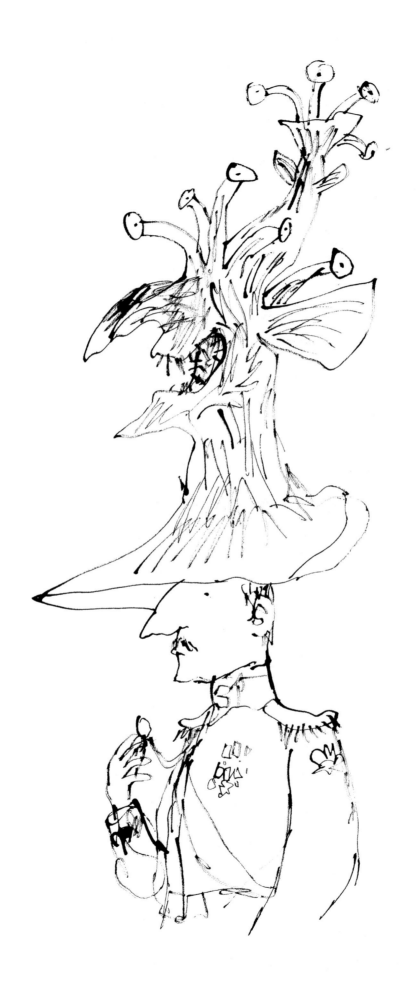

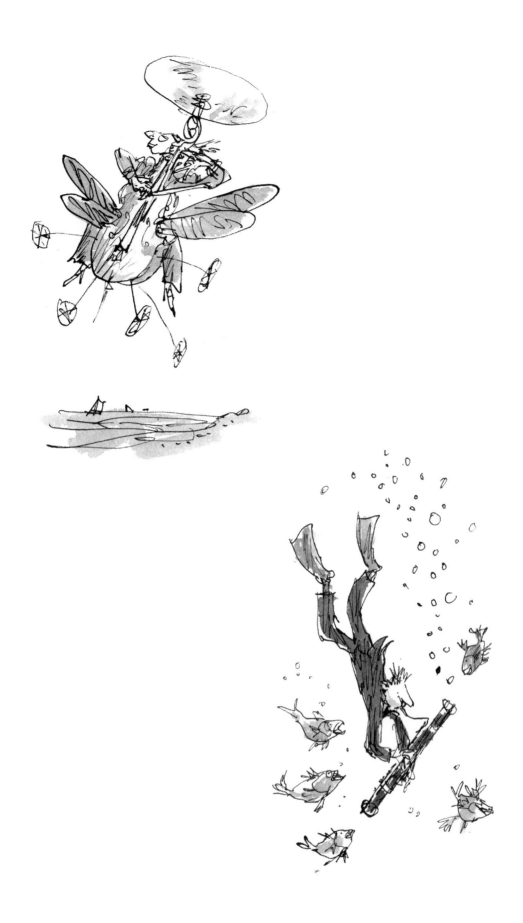

Aldeburgh

I first met Emma Chichester Clark when she was a postgraduate student at the Royal College of Art, and we have remained close friends ever since. Her husband, Rupert Wace, is a London dealer in ancient antiques, but they also have a house in Aldeburgh, where he has a shop of a rather different kind. It's called Objects, and in the summer of 2017 he invited me to think up twenty or so small drawings of objects to appear in the shop at the end of the year. He added: 'They ought to have wheels and wings.' It was a prompt I was grateful for, since it meant that I could carry on, at a diminutive scale, the fantasising that I had indulged in, often as large as possible, for the Jerwood Gallery.

I was able to salute Aldeburgh as a seaside resort with an improved beach hut, and also as home of the celebrated Festival, so that a cello now has wings and wheels and a bassoon is something you play underwater. I liked the idea of a sundial as something you can set your watch by, and a clothes peg as useful in getting your child from one place to another. I suppose what I like about the heirloom is that it invites the spectator to have their own view of what happens next.

Top: bathing hut. Bottom: sundial

Top: paper clip. Bottom: heirloom

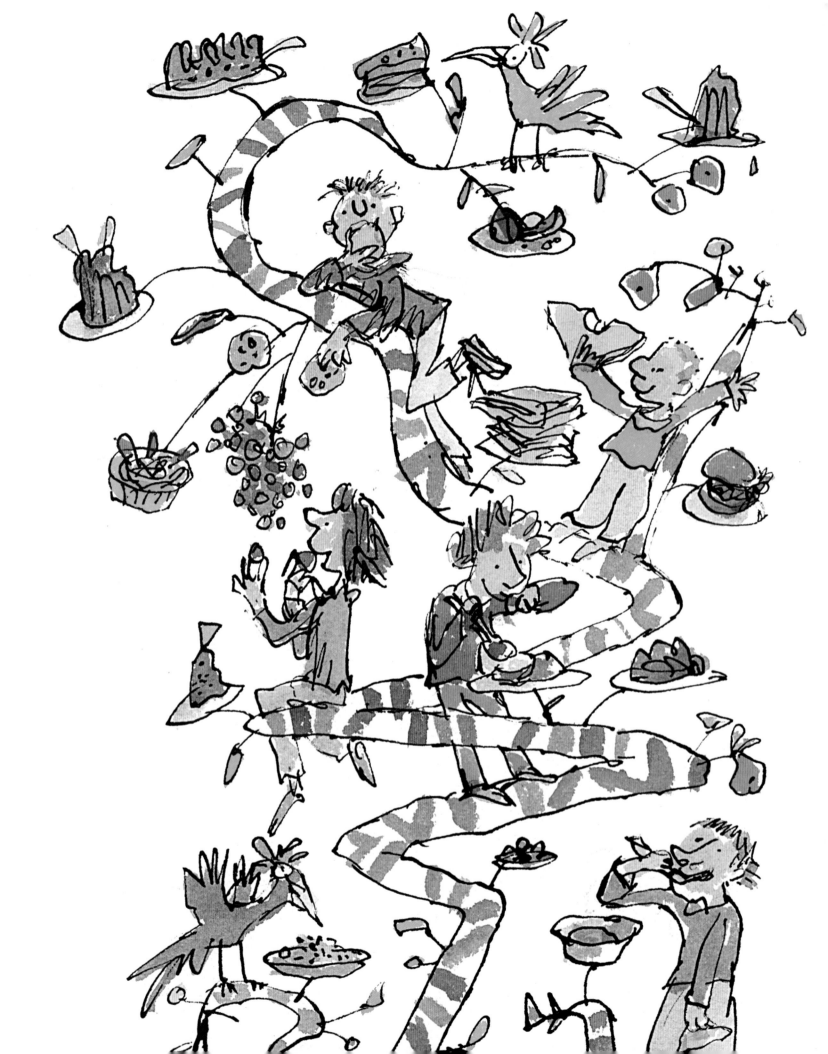

Berlin and Sidcup

There probably isn't much affinity that can normally be established between Berlin and Sidcup, but I have the pleasure of getting them both under the same section heading by the fact that I have an interest in a junior school in each of them.

I have explained in *Beyond the Page* how the Quentin Blake Europe School came to have my name on it, and described the memorable naming day. I have visited the school a few times since then, but as I became less and less inclined to undertake even such a simple journey as that, it seemed that something more permanent might be in order. What I was able to arrange was two mural panels, enlarged in the same way as a number of other projects recorded here, one to decorate an area where the children eat and another where they relax. The settings, too, have in common with other such projects that they make use of decorative trees, so that we don't have to bother with perspective and we get a good view of the children's various activities.

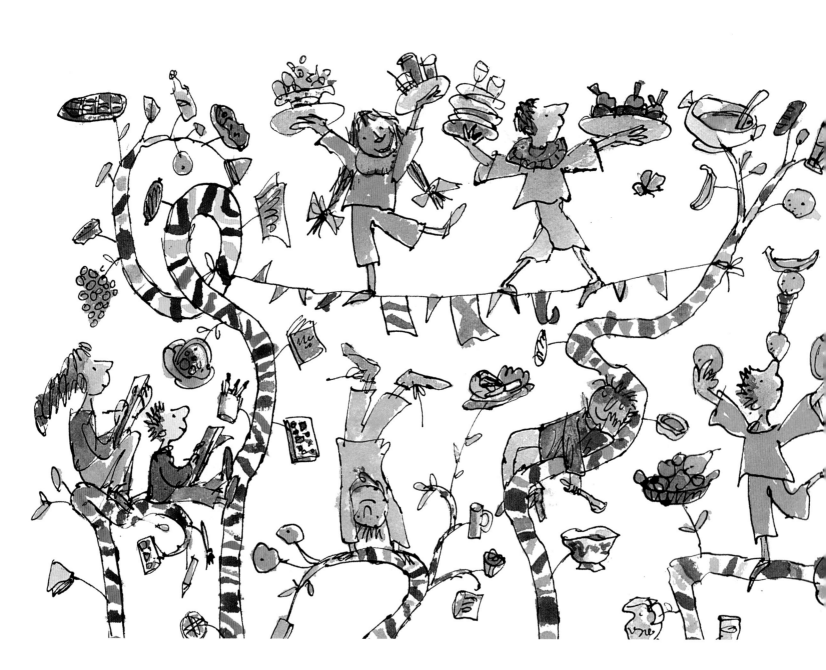

176

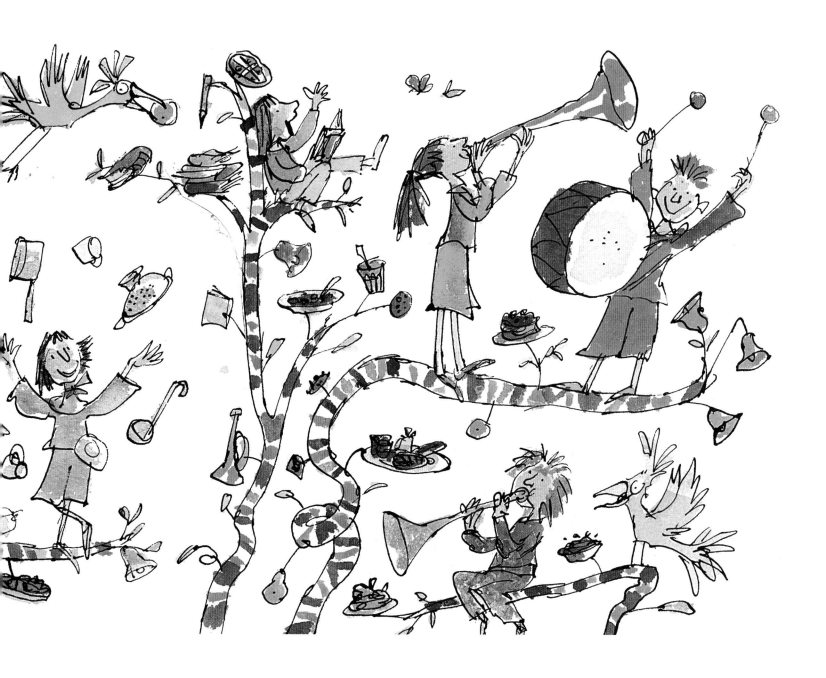

177

My relationship with the other school is rather different. It is – to give it its full name – the Holy Trinity Lamorbey Church of England School, which I first set foot in almost exactly eighty years ago. I remember the chiselled nose of Mrs Bolton, the formidable head teacher, and the generous blonde locks of Miss Bowles, who assisted her. I left when I was eleven to go to the local grammar school, and, as far as I can remember, have never been back. Since those days the school has left its original building and joined the local grammar school on the green spaces of a former golf course. There, recently, the school took the enterprising step of buying a London double-decker bus as a school library, and got in touch to see if I would visit the school to open it. I explained that nowadays I really no longer make visits, but I am always happy to draw – so would they like some drawings on the side of the bus? They would, and I was able to fill the panels formerly occupied by advertisements with pictures of an assortment of young readers.

Preliminary (above) and final (right) drawings for the Holy Trinity Lamorbey School library bus

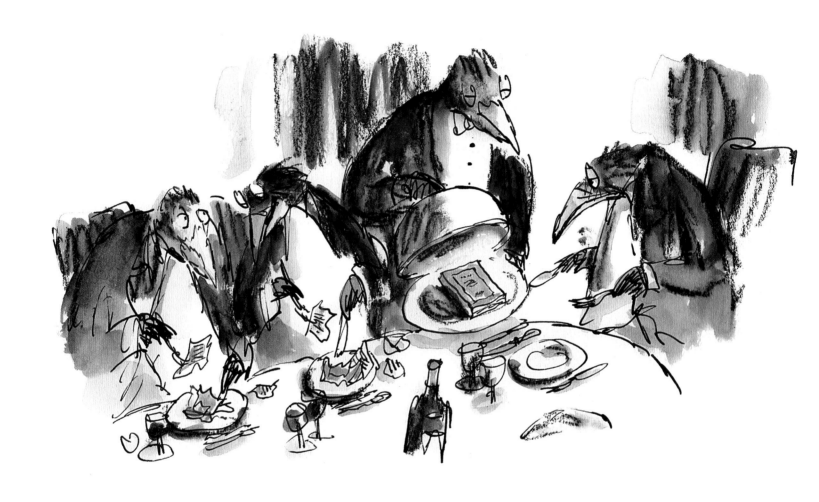

Paris

My many memories of Paris ventures range from decorating the lofty walls of the Petit Palais museum for an exhibition of paintings from their reserves to the exquisite little gallery of Martine Gossieux in the rue de l'Université, not least memorable for an encounter with the great Jean-Jacques Sempé.

The two projects I want to describe here, however, do not involve my going to Paris, though they did involve knowing – or, perhaps more accurately, imagining – something about French literary life, and in both cases I was able to make use of *The Life of Birds* – or *Nous Les Oiseaux* – to convey my observations without being specific about individuals.

Neither of these projects asked specifically for this solution. The French have a very clear sense of the *rentrée*, the time in September when everyone returns from the August break and everything starts again. At the same time the *rentrée littéraire* is when a surge of new books is published; a newspaper, *Le Figaro*, publishes a special supplement, *Le Figaro littéraire*. In 2015 I was pleased to be asked if I would decorate the issue with suitable illustrations. I reached for a parallel bird life and drew what I thought must be typical situations: a version of the lunch where the winner of the prix Goncourt is decided; a bookshop dedication session; the interviewer in pursuit of the authoritative opinions of the *grand maître*. I was also pleased that *Le Figaro* was able to print them in colour.

Some of the same characters and situations naturally found a place in my next project. Gallimard has an impressive series of collected classics, 'le Bibliothèque de la Pléiade'. If you buy two of these expensive volumes at the right time of the year, your bookseller will give you a matching leatherbound diary, the *Agenda Pléiade*. The early pages of the diary are decorated with drawings; I have seen, for instance, Picasso bullfighters and drawings of Romain Gary by Joann Sfar. I think mine is the only diary where the drawings have been created specially, and I can remember clearly the dinner when Antoine Gallimard, in London on business with his colleagues, turned to me and asked me if I would like to take on the task. I set about it with enthusiasm and birds. From the young writer eyeing his new novel in the bookshop window, via lady authors presenting their work, to the veteran reader at last exhausted and allowing the book to slip from his fingers. *Vive la lecture*.

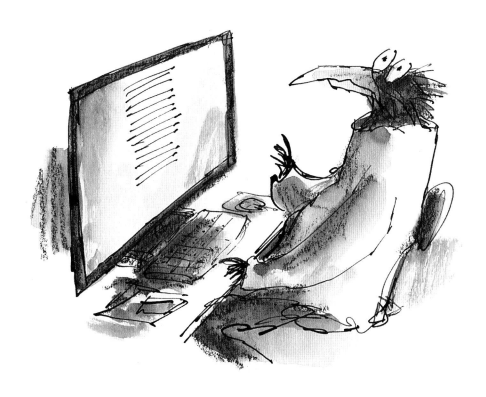

London: Hospitals

The Nightingale Project is the charity set up by Dr Nick Rhodes and Stephen Barnham to get art and music into hospitals. I am always grateful that it was they who, a dozen years ago, started me off working in this area. The most recent set of drawings is probably the most modest in its demands, but nonetheless very sympathetic.

Our idea was essentially of a collection of small pictures, each showing some common everyday activity that patients might have been taking part in outside the hospital environment. Such a collection would have been, with framing and hanging, both expensive and vulnerable. We redressed the situation by my producing a set of small drawings of various everyday activities – partly, of course, as with other hospital pictures, to keep the spectator in touch with ordinary life – and, having made a suitable arrangement of them, had them printed on washable wallpaper. Once on the wall they were safe and, if necessary, renewable.

The other two projects that I want to talk about here are strikingly contrasted in the situations they address.

St Bernard's Hospital Southall wall decoration

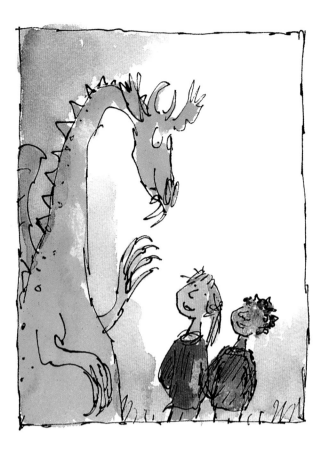

The first one was commissioned by Lucy Ribeiro of St George's Hospital in Tooting. She found that she had a sum of money – I think it was £500 – to invest in a new work for the children's department, appropriately called the Dragon Centre. As I discovered later, she had had a number of meetings with the staff and young patients of the department, and had put samples of the work of a number of artists before them for their reactions. I was their choice, but when Lucy first approached me I suggested that if we spent the money on printing and design we could have a number of pictures instead of one. There was nothing arduous about drawing a set of ten pictures – one a portrait of the dragon meeting two children, and nine others of (her? him?) going through various hospital experiences. Some were medical – having the tail bandaged, and what were those alarming spots? – but there were others, such as reading and drawing; and of course if you have a dragon you have a ride on it.

Burgess Design organised these images, enlarged and printed on to panels, slightly curved like large sheets of paper, along both sides of a corridor on to which the various consultants' rooms opened. I had the reward, on the day of opening, of seeing the consultants emerge looking as pleased as the young patients at what had arrived.

Dragon wall panels

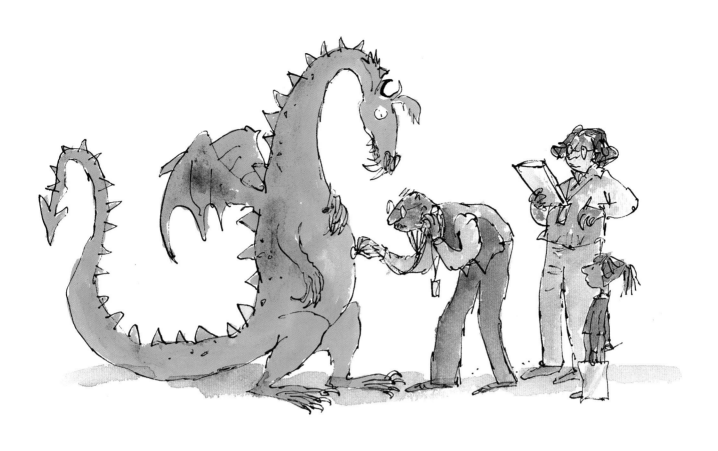

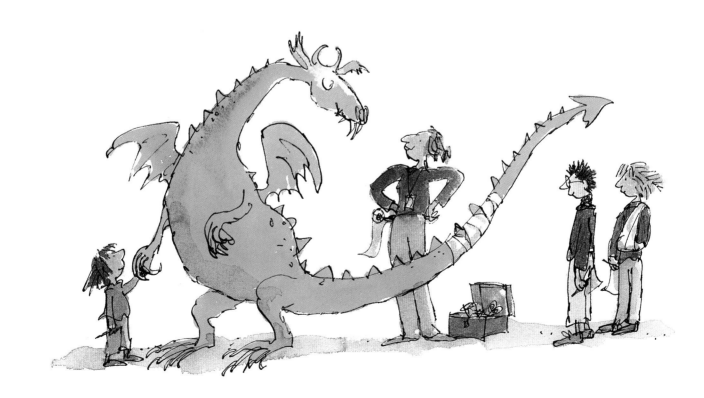

189

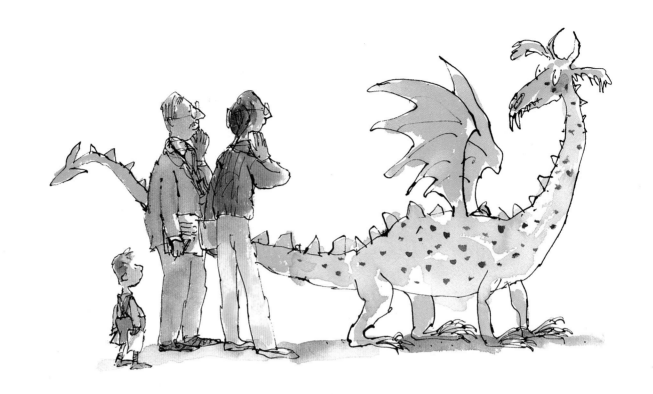

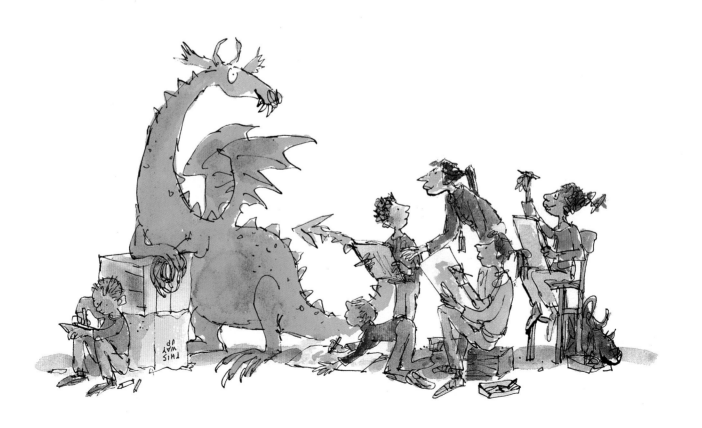

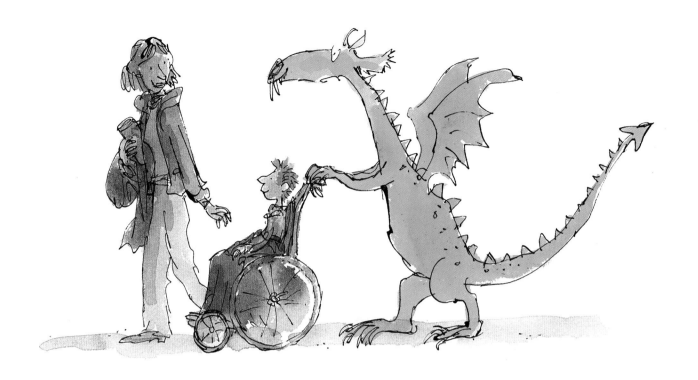

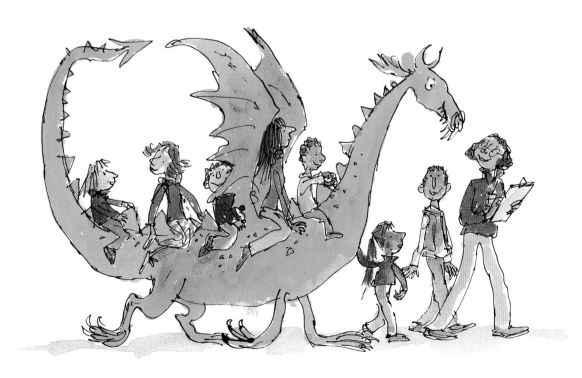

191

The other commission could hardly have been more different: I was approached by a young couple, Jenny and Michael Walker. Their son, Elliott, born in Great Ormond Street Hospital, was not to survive; in order that they could be with him for the end of his short life, they found themselves lodged overnight in a room intended for some quite other purpose. Later, aware that other young parents might find themselves in a similar situation, the Walkers asked if Great Ormond Street could find a suitable room; they would pay for its furnishing and decoration, and it would be called Elliott's Room. And, having seen some of my other work for hospitals, they asked me if I could create some pictures for it. By this time the hospital projects I had worked on covered many ages and situations, but I was aware that, though I was immediately prepared to respond to this young couple's positive and generous gesture, the response would have to be something of a different order. No place here for gambits of cheering-up, teasing, activity and optimism. However, as with previous projects I had taken the opportunity to consult both with patients and professionals, here I had the privilege of calling on the reactions of two people with first-hand experience.

The pictures, of course, were more for the parents than for the child and it seemed best for them to be small and framed, a note of domesticity in a room otherwise containing clinical equipment. I think it was Jenny who suggested the animals and we had rabbits, birds and horses. I suppose it was natural for the horses to be the nearest to human parents; obviously together, but with one looking elsewhere, with something to be aware of that we don't see. As far as I could discover, the drawing that people found most affecting was somewhat similar, of a couple on the beach, once again together but looking away – another situation where the spectator can make his own association.

LONDON IS OPEN
FOR SUMMER!

London: Money, Food and Drink

In 2012 I became a client of Hoare's bank. It's a private bank, and has the interesting distinction of having belonged to the same family since the end of the seventeenth century; several members of the Hoare family still manage the firm today. In the main building in Fleet Street each of the various meeting rooms has been given its own identity: one has pictures of Stourhead, the family seat of the Hoare family; another, pictures of former clients – Byron, Gainsborough, Jane Austen. I was invited to illustrate another such room. Hoare's bank still owns all its ledgers, with a distinctive black and white binding in vellum, and so I put forward the idea of a Ledger Room.

Though I use the identifiable contemporary binding of the ledgers, the drawings relate to different stages in the history of the firm. The bank also has a two-headed eagle as another of its symbols, and that proved to be useful in one of the nineteenth-century scenes. There are eight pictures in all; they first went into the public spaces of the bank, and I think still wait to come together in their own room.

The Ledger Room at Hoare's Bank

The Dorchester Hotel for Laurent-Perrier

Early in 2016 I was approached by Laurent-Perrier, the champagne company, to find out if I could make drawings of three hotels and a restaurant that were their clients. These images were to be used in press advertisements. I am not normally enthusiastic about advertising, and gave up working for it many years ago; however, it was interesting to be asked to depict architecture, something I am not often asked to but enjoy when I am. There is also the possible embarrassment of promoting a product you don't like or even disapprove of, but this was not the case here. The drawings were straightforward enough, with only two requirements. One was the relatively limited view of the buildings, which was the main entrance in part of the façade. The other was that as they were to promote a brut rosé champagne, there was a request that each should have a pink flush – a very specific pink flush, to which I was guided by cryptic messages from the Paris advertising agency that had the account.

My other encounter at about this time with something to drink was equally flushed. Peter Hill runs a private brewery in East London and needed a bottle label for a new beer. It was in a series where each label is designed and signed by an artist. On mine – I think I may have suggested the name Hackney Red – you see an artist (but not me) with a brush in one hand and a pint in another.

Hackney Brewery beer label

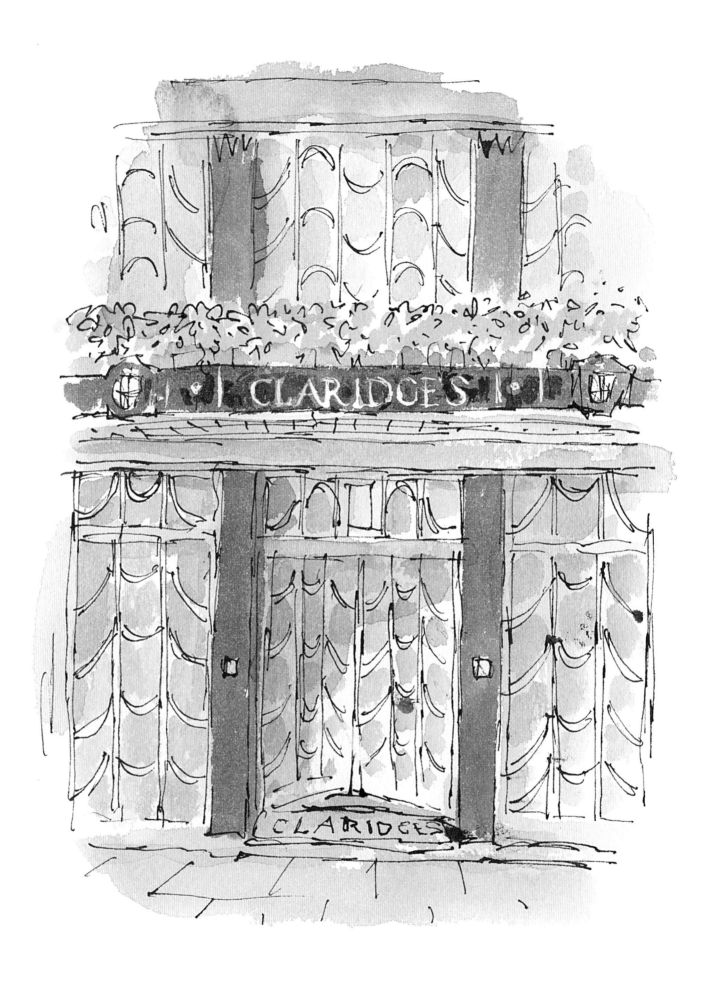

Hotel for Laurent-Perrier

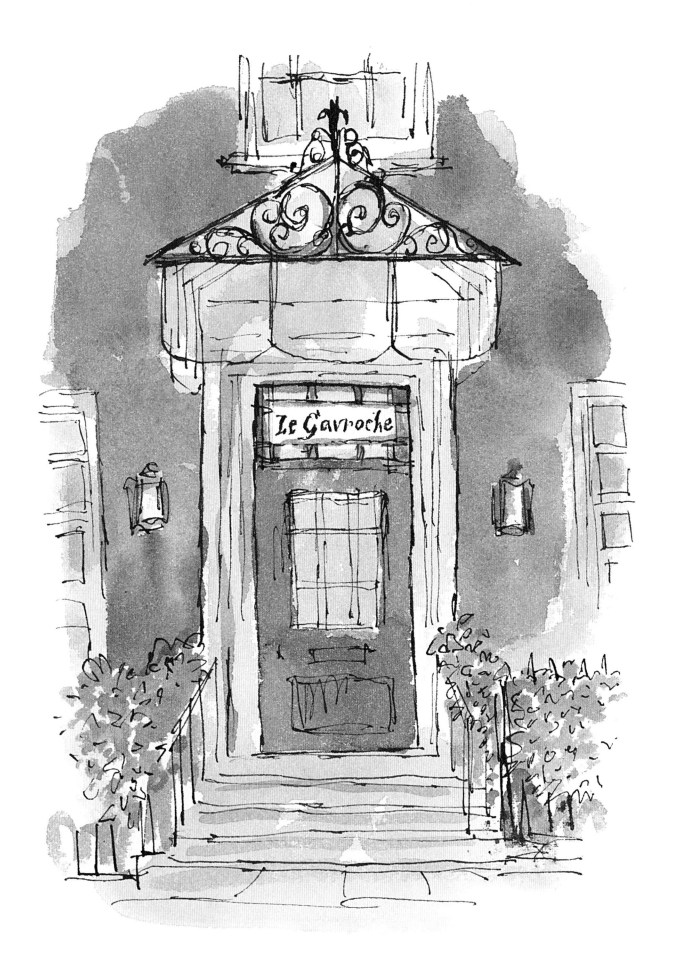

Restaurant for Laurent-Perrier

Sheekey's is the fish restaurant and oyster bar that has existed in St Martin's Court off Charing Cross Road for over a hundred years. In 2017 the name of the oyster bar was changed to the Atlantic Bar, and I was asked to provide a set of drawings to appear temporarily in the bar to mark the occasion, of which one would also appear on a plate. Fish and people underwater were already at the tip of my pen and so I was able to depict, swimming and accompanied by fish and seaweed, five representative individuals. A waiter and a chef were there, as well as a young lady raising a glass of white wine to her lips, and a substantial businessman raising an oyster to his. Sheekey's is in the heart of theatreland, so I drew a slightly bohemian character who I hoped might look as though he was in some way involved in the theatre (actor? director? designer?). At any rate, he was the one chosen to appear on the plates; the only disadvantage, apparently, was that the clients tended to steal them. I have to regard this as some kind of success.

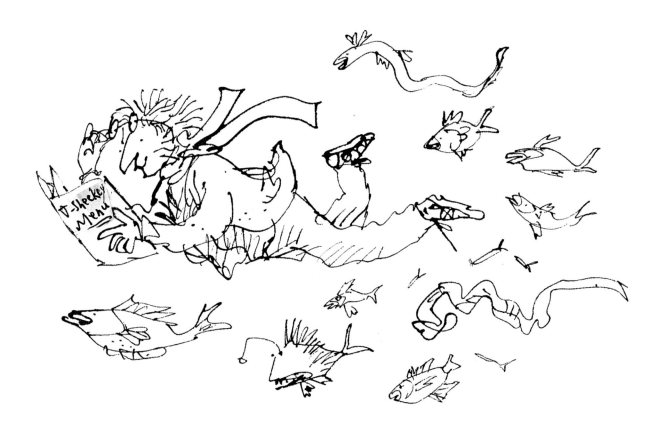

Drawings for Sheekey's Atlantic Bar

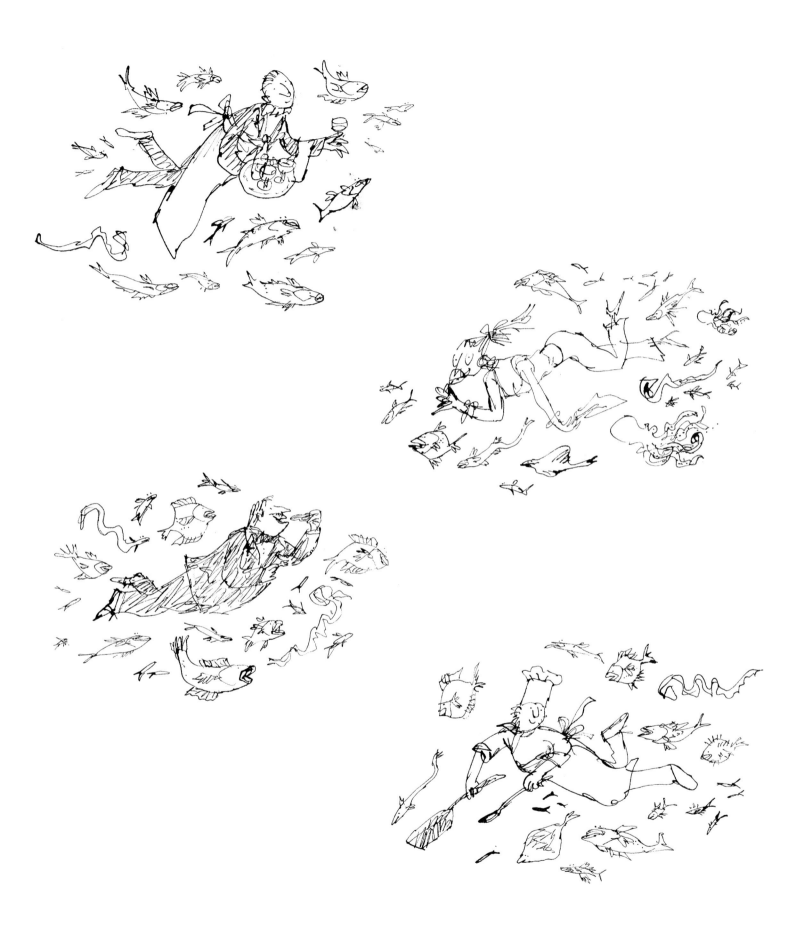

London: Music

James Blake was born in Hammersmith in 1988; his reputation as a musician and performer, however, is now international. Alexis Burgess brought him to see me, with the interesting suggestion that I might be able to provide the artwork for the sleeve of the vinyl version of his next album. I have very little understanding of music, but there was no mistaking the atmosphere of James Blake's. On his previous album I was also able to see a photograph of him walking towards the spectator. I took that characteristic silhouette and transferred it to an imaginary landscape, with crows and women in the trees. Once again, the work was required to appear in different sizes: on the digital recording and on hoardings in London and New York. The vinyl sleeve was followed by the poster for Blake's American tour. I supplied a drawing of Blake at the piano, and a dark scene of various underwater life (one or two of the women seemed to have got down from the trees to join the sharks), which Burgess organised beautifully with light rising from the open top of the grand piano. The poster exists in two sizes, large and enormous.

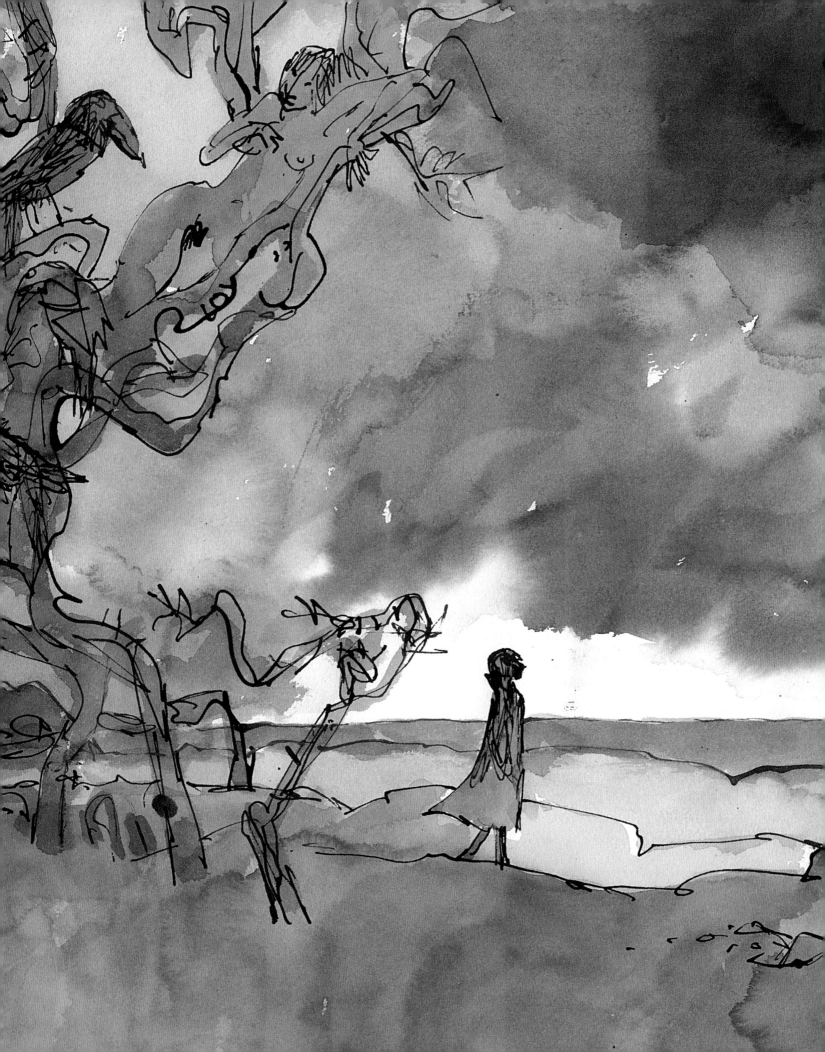

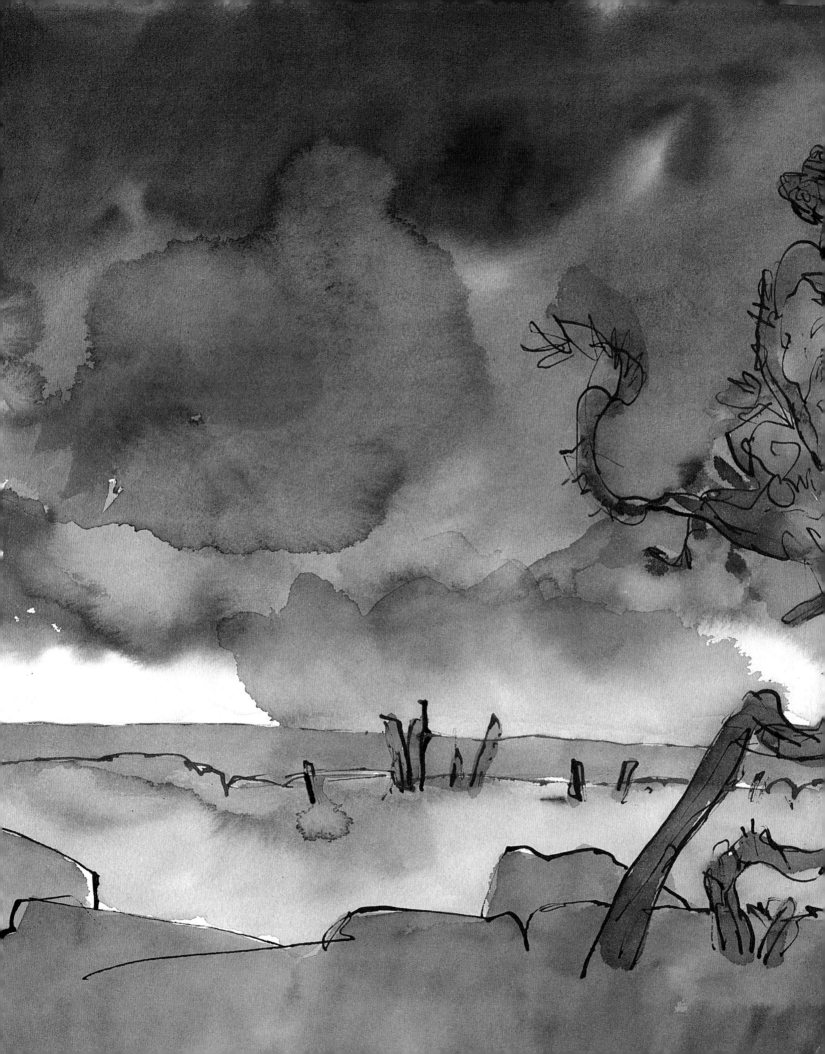

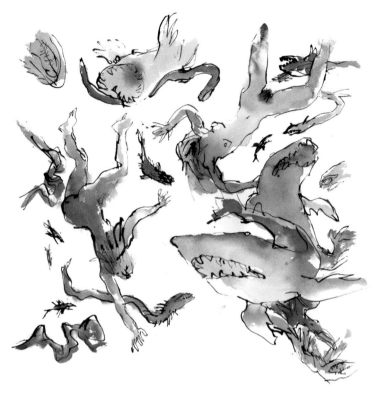

Elements of James Blake tour poster

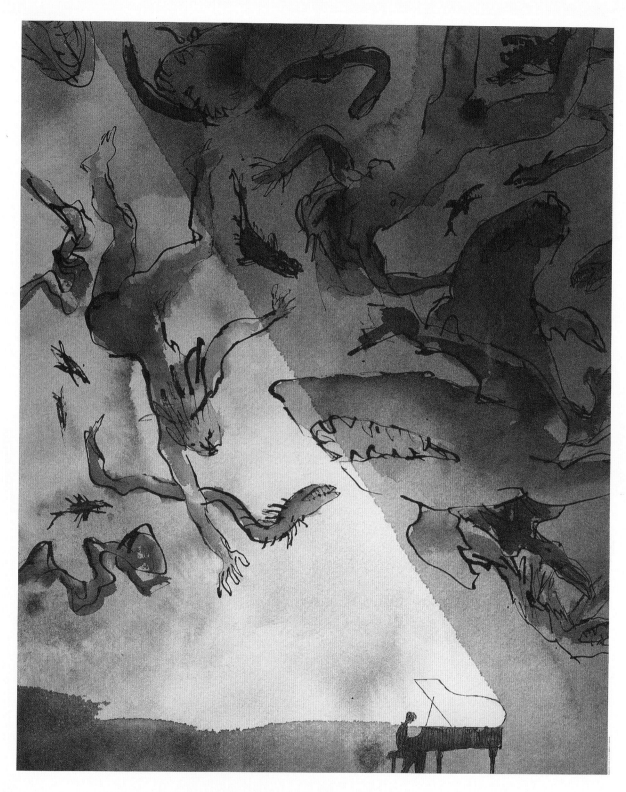

James Blake tour poster

211

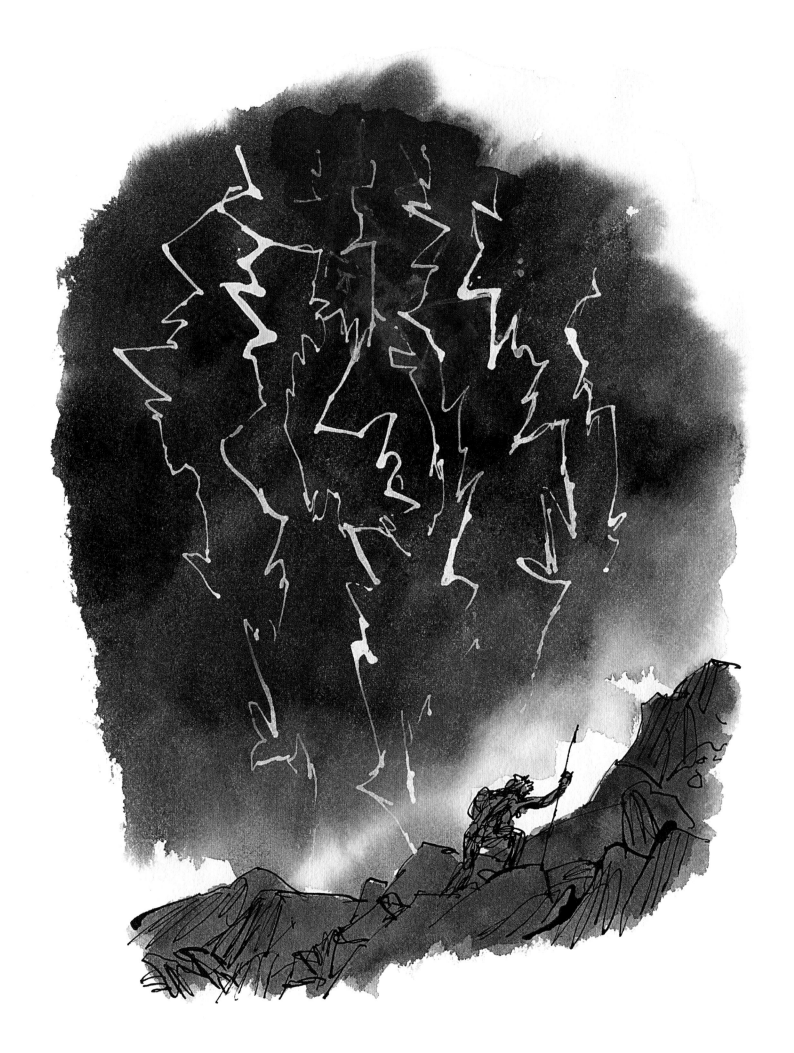

The Golden River

I can't begin to guess how long I have had my copy of Ruskin's *The King of the Golden River* – it could easily be forty years. The book itself is much older than that; it's a reprint (published by George Unwin at Sunnyside, Orpington, Kent) of the original of 1851. It's a small, slim, squarish volume with a decorated red cover, and (which is why I am sure I bought it in the first place) it is illustrated by Dicky Doyle, an early Victorian artist for whom I have a great respect. The book is illustrated in what is quite a curious way. There is an elaborate title page, with a country scene and the characteristic rusticated lettering of the period. Facing it is a frontispiece, which is in itself a small masterpiece: South West Wind Esquire banging the doorknocker and little Gluck looking out of the window in amazement. Compared with this striking and authoritative image the remaining illustrations are small and modest. Dicky Doyle gets a remarkable sense of landscape into these tiny images, but in the nature of things they remain relatively undramatic.

Ruskin wrote *The King of the Golden River* for Effie Gray, the 12-year-old daughter of some friends. (Later, grown up, she was married to Ruskin briefly and unsatisfactorily, before she found happiness with the painter John Everett Millais.) The story was not intended for publication, which may explain the way that it contains effectively two stories, one with the appearance of South West Wind Esquire, and the longer account of the King of the Golden River himself. However, there is nothing perfunctory about the writing, and one is soon aware of the attention to detail, the strength of the folk tale-like structure, and the way that the story resolves with a resonant crisis of conscience. (Huckleberry Finn finds himself in a comparable but very different situation.)

For most of the time that I owned the book it had never occurred to me to think of re-illustrating it, and I am still not quite sure how I managed to get past that commanding figure at the entrance. Partly, I suppose, work for the Folio Society, where I found myself illustrating books that had already been illustrated by other artists in former times; partly from having come to know more about Ruskin himself, including his passion for mountains, glaciers, weather. It was difficult for those interests to be reflected in 1851, but modern colour printing allows us to do it.

I was fortunate in being able to take my ambitions for the book to Roger Thorp. He is an editor passionate about children's books of every period and had just moved to Thames & Hudson to start a children's list there. He warmed to the idea, and we settled on a book of sixty-four pages, about a third of which would be available for illustrations. A book with such a quantity of pictures has to be designed throughout to fold in words and drawings together, so I set to work with a dummy of the book and, in the old-fashioned way, cut up a text of the story to stick into position, and drew in extremely rough indications of the illustrations where I thought they should go.

I suppose my most usual practice would be to make another set of more developed roughs, separate from the book, and put those on the lightbox to work from. On this occasion, however, I simply photocopied all the pages and enlarged them all slightly (my sight is no longer very good at detail) and worked from them. Somehow I felt so positive and enthusiastic about the book that I was eager to imagine myself into the characters and the situations and, unusually, succeeded in not having to draw any of them more than once, completing all thirty or so, in black and white, in about four days. I confess that there was just one that I had difficulty finding the answer to, and put in three afternoons before I managed to resolve it. I waited some time before setting about the watercolour treatment: it was not just a question of colouring in the drawings because the strange effects of weather, of clouds, mist and lightning and their emotional charge, are all essential to telling the story. I felt very fortunate that I had (at last) discovered that I had such an incomparable opportunity for illustration.

Index

Exhibitions

February – May 2013
Quentin Blake: Drawn by Hand
Fitzwilliam Museum, Cambridge

December 2013 – January 2014
Quentin Blake: Fireworks, Fanfares and Fancies!
Chris Beetles Gallery, London

April – October 2014
Nos Compagnons
Galerie Martine Gossieaux, Paris

July – October 2014
Artists on the Beach
Jerwood Gallery, Hastings

July – November 2014 (and UK tour until 2018)
Quentin Blake: Inside Stories
Inaugural exhibition at House of Illustration, London

May – June 2015
Quentin Blake: Words and Pictures
Quentin Blake Art Building, Sidcup (part of Sidcup Words & Music festival)

July – September 2015
Life under Water: A Hastings Celebration
Jerwood Gallery, Hastings

July 2015
A Quentin Blake Summer – with wind, dogs, kites and extra ducks
Chris Beetles Gallery

November 2015 – May 2016
Quentin Blake: The Hospital Drawings
South Kensington & Chelsea Mental Health Centre, London

June – October 2016 (and UK tour until 2019)
The BFG in Pictures
House of Illustration, London

December 2016 – June 2017 (and UK tour until early 2019)
The Roald Dahl Centenary Portraits
British Library, London

April – June 2017
The Bulging Portfolio of Quentin Blake
The Artworks, Halifax

June – October 2017
Quentin Blake at the Folio Society
Heong Gallery, Downing College, Cambridge

June – October 2017
The Only Way to Travel
Jerwood Gallery, Hastings

September 2017 – June 2018
Billy and the Minpins
Roald Dahl Museum & Story Centre, Great Missenden

November 2017 – March 2018 (and South Korean tour until September 2018)
Quentin Blake
KT&G SangSangMadang, Seoul, South Korea

December 2017 – January 2018
Quentin Blake drawings
Objects, Aldeburgh, Suffolk

January – April 2018
Moonlight Travellers
Jerwood Gallery, Hastings

Summer 2018
Walking with the Birds
Jerwood Gallery, Hastings

October 2018 – January 2019
100 Figures
House of Illustration, London

Autumn 2018
The World of Hats
Jerwood Gallery, Hastings

In House of Illustration's Quentin Blake Gallery

April – September 2016 (and UK tour until 2017)
Seven Kinds of Magic

September 2016 – February 2017
The Tale of Kitty-in-Boots

February – May 2017
Linda Kitson: Drawings and Projects (curated)

May – October 2017
The Life of Birds

October 2017 – February 2018
Quentin Blake & John Yeoman: Fifty Years of Children's Books

February – April 2018
Arrows of Love

May – September 2018
Quentin Blake: Voyages to the Moon and the Sun

October 2018 – January 2019
The Model as Artist

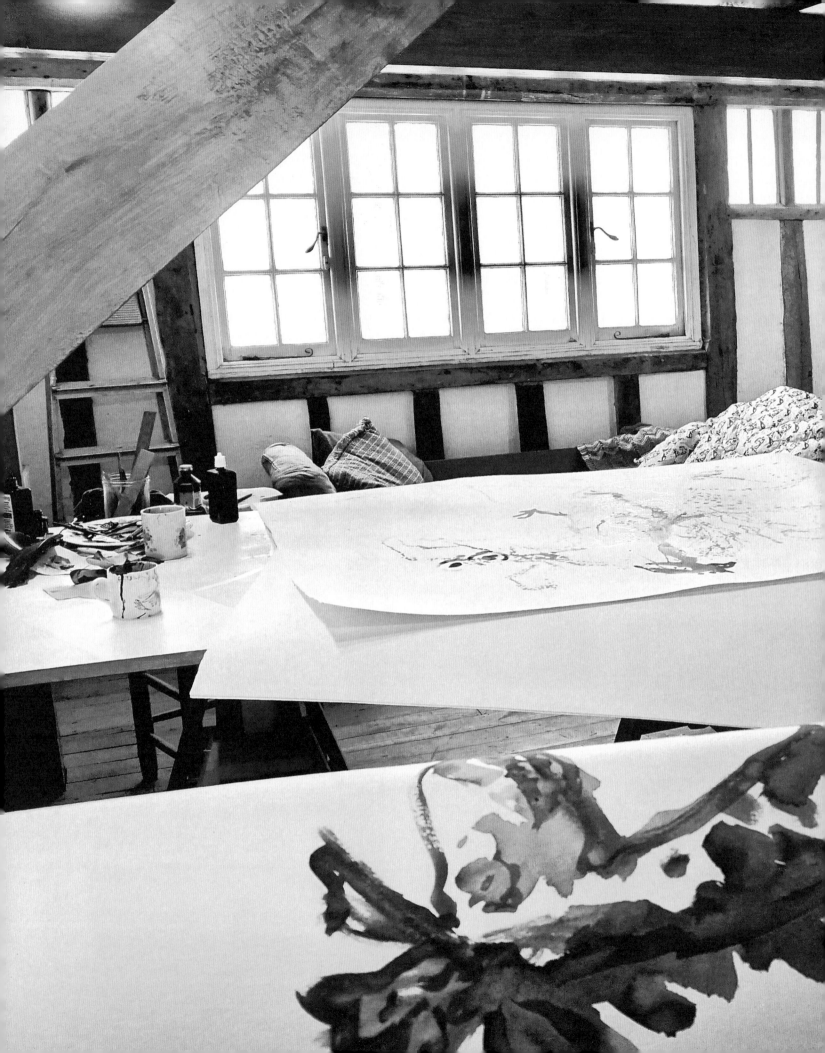